THE BIG ACTIVITY BOOK FOR DIGITAL DETOX

P9-CFN-648

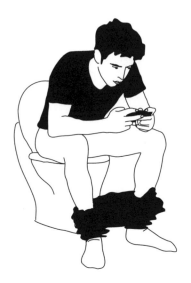

THE BIG ACTIVITY BOOK FOR DIGITAL DETOX

JORDAN REID
&
ERIN WILLIAMS

A TarcherPerigee Book

tarcherperigee

an imprint of Penguin Random House LLC
penguinrandomhouse.com

Most Tarcher/Penguin books are available at special quantity discounts for bulk purchase
for sales promotions, premiums, fund-raising, and educational needs. Special books
or book excerpts also can be created to fit specific needs. For details, write:
SpecialMarkets@penguinrandomhouse.com.

ISBN 9780593085905

Printed in the United States of America
10 9 8 7 6 5 4 3 2 1

Book design by Laura K. Corless

For Lucy, River, and Shea:
May you one day read these words on actual, IRL paper,
rather than on the holographic imaging app implanted on the insides of your eyelids
via some technology created by the love child of Jeff Bezos and Elon Musk.

Homo erectus
iPhone handius
↓

DEAR READER,

Oh, hello there! Are you in need of a digital detox?

That was a trick question. If you are alive—and presumably you are, as you're currently reading an activity book and artificial intelligence robots have better things to do than word searches (at least for now, while they're busy taking over the world)—you need this book.

Look, it's not that the digital age is *bad*, per se. It's just . . . a lot. A hundred years ago, our brains were just starting to handle the idea that we could move at a speed faster than "horse," movies were still "moving pictures," and the toaster was busy blowing people's minds with its innovative capacity to toast things.

Fast-forward to now, and we're holding virtually unlimited information in the palms of our wildly unqualified little hands, having sex in cars that drive themselves (caveat: This is still a bad idea, even if it sounds really fun), printing 3-D body parts, and diving to the depths of the ocean while sitting in our living rooms with Space Invaders–style helmets on our heads.

Like we said: It's a lot. And the reality is that our brains simply haven't evolved at the same speed as technology, leaving us feeling discombobulated by all the beeps and boops and

brand-new apps that we HAVE TO HAVE RIGHT NOW. (Spoiler: You do *not* need that app, or that thing you are thinking of buying on Amazon. Put. Down. The. Phone.)

This book is here to remind you that yes, the Internet is terrible (that's Chapter One), but also that change is both inevitable and sometimes beautiful. Just for today, though, go ahead and take it off-line. Turn your devices to airplane mode (maybe call your mom first so she knows you're not dead), do a maze or two, and remember that there was life before Facebook, and it was good.

Sending you all our (analog) love,
Jordan and Erin

HOW TO USE THIS BOOK

1. Pick it up whenever the mood hits: In the morning, instead of checking your Insta feed (spoiler: Your cousin Sherry is #livingherbestlife); during your lunch break, so that delicious corned beef sandwich is something you actually taste as opposed to something that you mindlessly inhale while watching YouTube clips of cats falling off windowsills (which, okay, are always funny); late at night, if you're the kind of person whose sleeping patterns don't benefit from the presence of blinky screens and endless news feeds heralding the latest political dumpster fire.

2. This book is loosely divided into sections, but it's also an activity book and therefore does not possess anything resembling a coherent storyline. It also has actual pages made from actual paper, and you can flip them forward and backward at whim. You can even turn down a corner to keep your place and come back to it later! Retro.

3. If you're so inclined, take a picture of your detoxifying process and tag us on Instagram @bigactivitybook! Make sure to include #ironic.

THE INTERNET IS TERRIBLE

ALL ABOUT ME

Hello, my name is _____.

I am _____ years old, which means that the social media channel I spend the most time on is _____. This fact makes me feel _____.

Here are three things I really like about the Internet:

1. _____

2. _____

3. _____

And here are three things that make me want to throw the nearest MacBook Pro off a very tall building:

1. _____

2. _____

3. _____

My guilty Internet pleasure is:

(a) Porn. Obviously.
(b) Shopping. Obviously.
(c) BuzzFeed articles.
(d) Dr. Pimple Popper videos.
(e) Videos of animals that have been groomed into the shape of large snowballs.
(f) Videos of people who have recently been sedated.

TELL ME MORE

If I could give Siri a new name, it would be:

(a) Alexa, hee.
(b) Nokia, because I'm old school like that.
(c) The Man, because she's watching me.
(d) My Precious, because she is.

I am currently holding this book in my hands because:

(a) I spend (significantly) more time with my phone than with my significant other.
(b) Aunt Debbie thinks the fact that I post daily photos of my cat is "oversharing" (she is wrong #catlady4eva).
(c) My Secret Santa apparently feels that I need to take my Tinder habit down a notch.
(d) Last night I dreamt that I accidentally posted an unretouched shot to Instagram and OMG it was so scary.
(e) I think in emoji now.

When I consider the possibility of decreasing my digital footprint, I feel:

(a) Excited.
(b) Relieved.
(c) Terrified.
(d) Anxious.
(e) All the above, and also I already posted about my awesome new digital detox activity book on Facebook. Obviously.

SELF-PORTRAIT, PLEASE

(THE O.G. SELFIE)

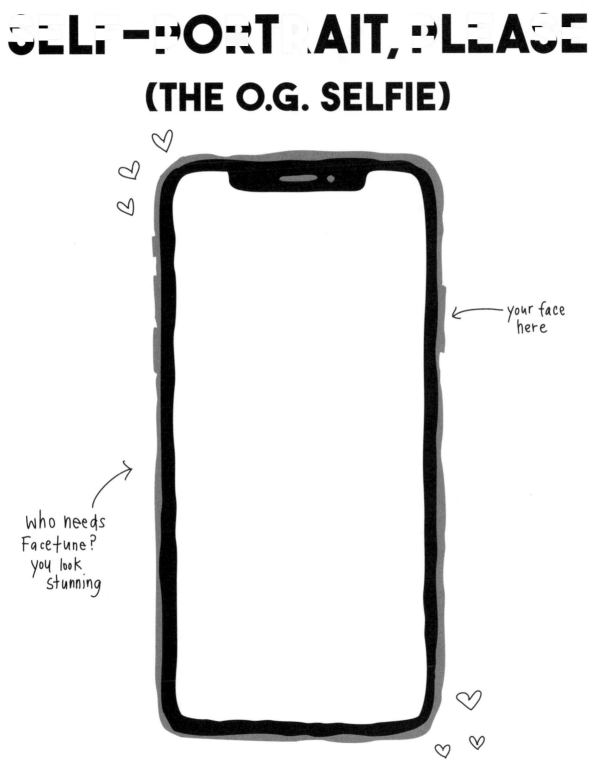

your face here

Who needs Facetune? you look stunning

REALLY
UNFORTUNATE THINGS
THE DIGITAL AGE
HAS GIVEN
US

1. **Chatroulette**: That thing where you "meet interesting new people!" but it's actually just creepers being creepy.

2. **Super monopolies**: In which the Everything Store makes Walmart look like a quaint neighborhood boutique.

3. **Trolls**: Somebody on the Internet is wrong, and you can be sure that these emotionally evolved folks are going to show up to set things straight. And they are going to be LOUD.

4. **Constant and ongoing awareness**:
 Of Justin Bieber's relationship status,
 emotional state, and haircuts.

5. *Sharknado*.

Three things that I have seen on the Internet and can now never unsee:

1. _____
2. _____
3. _____

This one was the worst. ──────┐
 ↓

(When you're done drawing, feel free to go ahead and scribble over it to erase it from
this book, if not your mind.)

GARNISH THE AVOCADO TOAST

Quick: Try to calculate the number of times you've seen a picture of avocado toast on your social media feeds. You can't do it. It's too big. (But the basic calculation is the number of people you follow minus the number of people you follow who have actual jobs divided by .68. Then multiply that number by 1,260 if you live in California or have people in your life who refer to themselves as "influencers.")

On the bright side, now you know that a sprinkling of chives will make this top-down drawing of your brunch really pop.

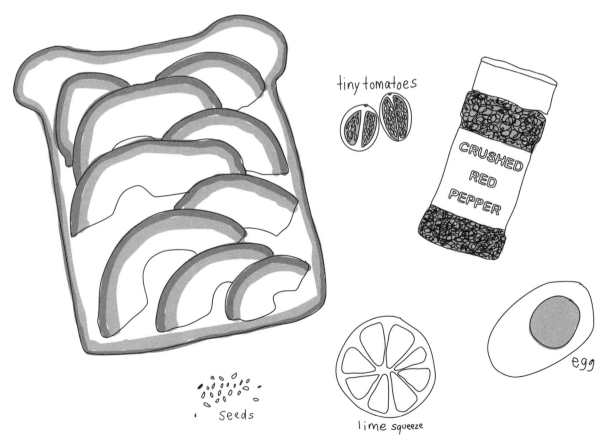

tiny tomatoes

CRUSHED
RED
PEPPER

seeds

lime squeeze

egg

WHAT IS THIS INFLUENCER LYING ON?

Woke up to another rainbow! #soblessed. So #grateful to all my fans who are coming with me on this #beautifuljourney! #lovemylife #gratitude #love #motivation #soinspiring #jesuslovesme #andyoutoo #positivevibesonly #bookstagram #love #ootd #beautiful #cute #fashion #happy #tbt #instagood #instalove #instafeels #allthefeels #feels #feelings #ad

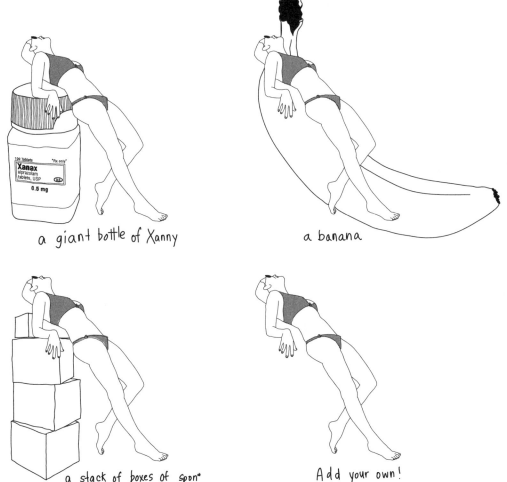

a giant bottle of Xanny

a banana

a stack of boxes of spon*

Add your own!

* Items influencers are sent for free and paid to sell

MEN WHO ARE DEFINITELY ON TINDER

Thank god for the Internet, otherwise you might never have come across these delightful specimens of humanity.

Men taking shirtless mirror selfies

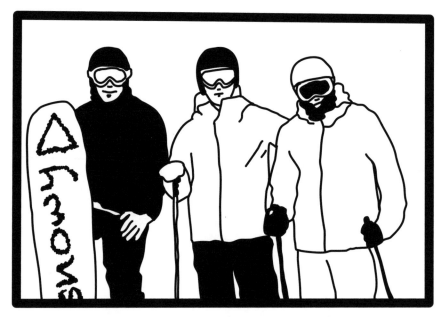

Men with skiing/snowboarding pics

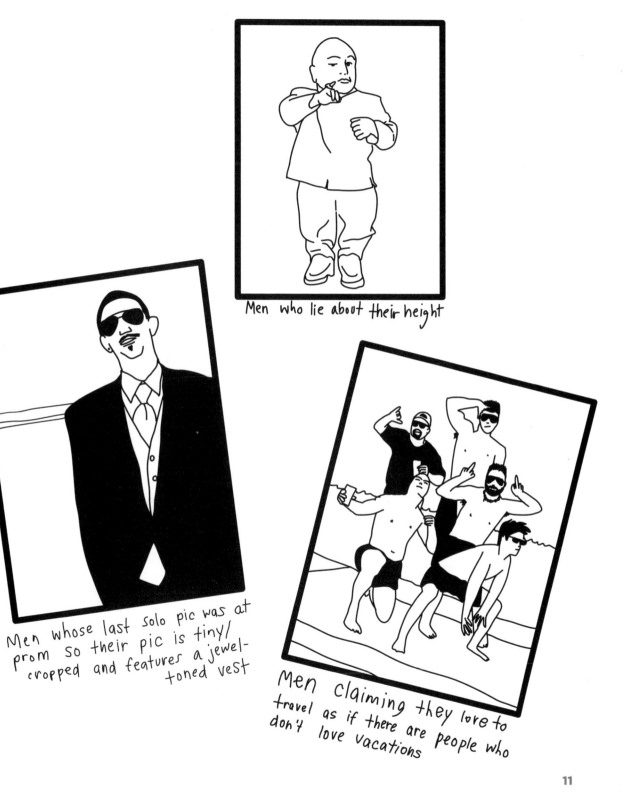

Men who lie about their height

Men whose last solo pic was at prom so their pic is tiny/cropped and features a jewel-toned vest

Men claiming they love to travel as if there are people who don't love vacations

THE SOCIAL MEDIA DIET

an açai bowl, a hand

a sushi roll,
a hand

Draw the last thing you ate, for posterity:

soft serve

HOW MANY WORDS CAN YOU MAKE OUT OF THE LETTERS IN "FACETUNE"?

TEA

TUNA

ALEXA: WHO IS SHE?

The robot lady who knows exactly how frequently you converse with your cat, that's who.

Check off all the things that Alexa has definitely heard you do. Tally up your points to see how badly you could be blackmailed by a mouth-breathing seventeen-year-old hacker.

- ❏ Heave-cried during an episode of *Grey's Anatomy*.
- ❏ Watched *realllly* a lot of porn.
- ❏ Eaten a burrito and then ordered a second burrito.
- ❏ Sung Adele using that second burrito as a microphone.
- ❏ Microplaned your calluses.
- ❏ Looked through dating app matches on the toilet.
- ❏ Smelled an intimate item of clothing when deciding whether to put it on.
- ❏ Taken twenty-plus photos of yourself without makeup on to see if you could rationalize posting a photo with the caption #iwokeuplikethis.
- ❏ Located earwax with fingernail. Wiped earwax on nearest available surface.
- ❏ Let your cat sit on your lap while you peed.
- ❏ Lip-synched in the mirror to find out whether you'd look sexy in a music video.

SCORING:

1–3 points: You are lying. And if you're not, you don't deserve this book.

4–7 points: You are also lying. But we get it: It's hard to admit that you let your cat sit on your lap while you pee. Even to your activity book.

8–11 points: You are a very honest human being. Congrats.

COLOR IN THE 5 SOBBING
MEREDITH GREYS

EMAILS YOU CAN IGNORE

Feel free to click that little trash icon (so satisfying!) without giving even a glimmer of thought to opening up emails from the following:

- Any and all "lifestyle brands," especially ones trying to sell you crystal vagina eggs or $300 skin creams.
- Companies warning about your credit score, because ignorance is bliss.
- Someone you knew peripherally in high school who has a cousin whose best friend's brother needs to raise $9 million for toe surgery.
- A clothing store you gave your email address to in exchange for 10 percent off when you shopped there once at age fourteen.
- Penis pump companies.
- Anyone who feels the need to write an ALL CAPS SUBJECT LINE, because nothing is that fucking important.

← SPAM, embodied

MEET SINGLES IN YOUR AREA INCREDIBLE DEAL SERIOUS CASH TRUE LOVE

Journal:

I get *so much spam* telling me to buy these things:

1. _____

2. _____

3. _____

I feel very _____ about this.

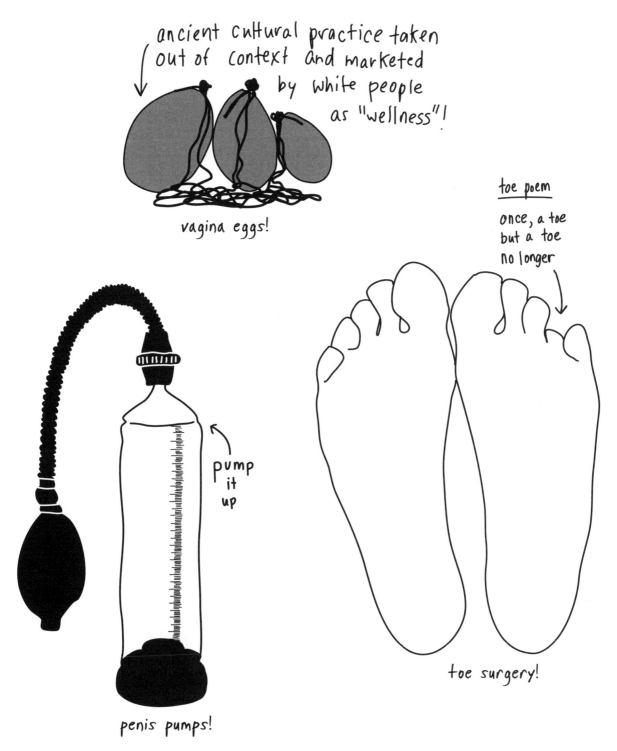

ancient cultural practice taken out of context and marketed by white people as "wellness"!

vagina eggs!

toe poem

once, a toe
but a toe
no longer

pump
it
up

penis pumps!

toe surgery!

17

WHAT ARE THESE PEOPLE STARING AT?

The deeply furrowed brow. The intense, unwavering gaze. That guy across from you on the subway staring into his phone like it holds the answers to all the universe's greatest questions is definitely thinking about . . . something.

Fill in your best guesses.

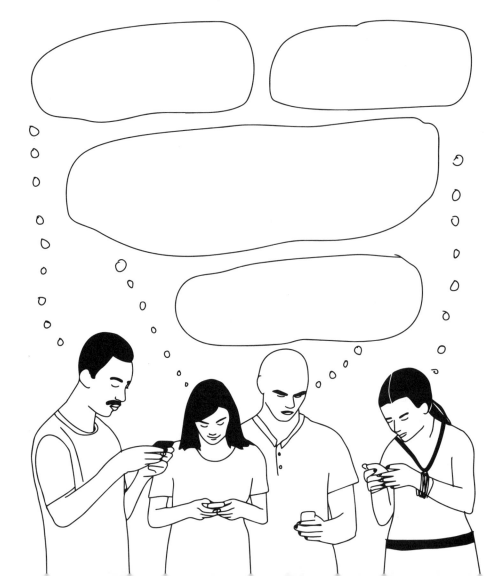

WORD ASSOCIATION TIME!

Write down the first word that comes to mind when you read each of the below. Bonus: Give any of the things you've never heard of a nice, satisfying slash-through, and revel in your selective ignorance.

Bitcoin: _____

Facebook: _____

Nudez: _____

Digital footprint: _____

ASMR: _____

Tinder: _____

Twitter: _____

Hacker: _____

The Cloud: _____

Inbox: _____

Firewall: _____

Anime: _____

Software update: _____

Influencer: _____

Emoji: _____

Hashtag: _____

Journal:

Doing this exercise made me want to check my _____.

I am/am not going to indulge that desire, which makes me feel _____.

WHAT'S LIVING ON YOUR PHONE?

Fact: Your phone is ten times dirtier than a toilet. And you spend an average of three-plus hours a day rubbing it onto your hands and face! Good times.

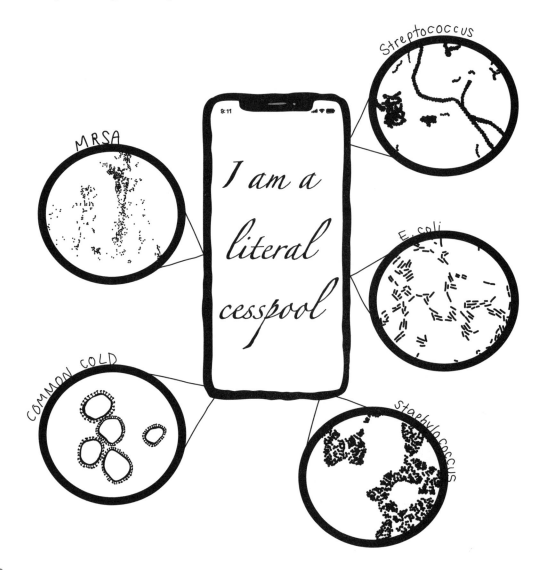

PLACE THE SITUATION ON THE PAIN SCALE

 1

 2

 3

 4

 5

6

DEAD

_____ Got a text

_____ Got a phone call

_____ Got a news alert

_____ Apple released a new version of something

_____ Apple went bankrupt and is no more

_____ Forgot headphones at the gym

_____ Forgot headphones on the plane

_____ Butt-dialed an ex (this one: _____)

_____ Someone wants to talk on the phone

_____ Someone wants to meet in person

_____ Someone saw your browser history

_____ Your mom is on a dating app

_____ Your ex is on a dating app

_____ You are on a dating app

_____ Your Instagram got deleted

_____ Your Facebook got deleted

_____ Your Twitter got deleted

_____ Your entire digital footprint got deleted

_____ Moved to Nebraska to live off the grid

NICHE DATING SITES

You look hot in that top

Looking to meet a fifty-plus golfer with a thing for mullets and pot? There's an app for that!

SPICY!

FIRE
HOT SAUCE

FAT BASTARD DATING

BIKERKISS

LOVE HORSE*

SEA CAPTAIN DATE

STD MATCH

TALL FRIENDS

VAMPERSONALS

CLOWN DATING

FARMER WANTS A WIFE

COUGAR LIFE

SINGLES WITH FOOD ALLERGIES

MEET AN INMATE

UGLY SCHMUCKS

POUNCED**

GLUTEN FREE SINGLES

PURRSONALS

DATE MY PET

HOT SAUCE PASSIONS

DIAPER MATES***

*Not what you think; hush.
**A dating site for Furries. Yes.
***For parents of toddlers looking to meet other parents of toddlers, or for grown-ups who like wearing diapers? (The latter. Of course.)

```
S K C I S P T O U U J P X B T Y O S H A F U T V S C N B K P
T E W O Q E O E D B T R L K C R G E C Q N U P D D L I V F F
T N I N U J H L P P Z Z U N N N Z L T D O L F Y N K Z U S Z
L X V G J G J K D Y E H W F I C W G A N F F D B E Y M K H I
E W N E R J A E J Y M K O T O L V N M M E R F R I K P F H I
T F H U D E C R Y S S E A C D E M I D N Y S K J R Q O D F Z
D U G W O N L O L I X D T V W G V S T P L I I N F W S L M V
P C Z D U G J L M I D X K A Y Y Y E S K S D F X L C B H A G
U I J O F K Q S A R F S P B D M H E J S M G E Q L N G M N I
R W P V I C S H A D A E Y X M H O R F I P D X H A H P I C Q
R S I E U C P T O S O A K B U P J F H X B B I T T E T V A A
S C W B P M S K K T K O W Y P J P N J T X H O N R A V D I N
O A E X H A V T L D S C F Z F D R E P A G H I S D P L Y Y F
N M J D B J E I M V K A U H E U X T P Q L V O N I C J N G R
A W L T E Y C X N S J M U M T Y F U A S F N W D K Z G Q F W
L T A U Y M S V Q G D M Y C H I U L N O A O I E A Q S H B J
S F E T A M N I N A T E E M E C W G B L L S K Q P N S E D W
M F J J Q V M J X Q U U A P G P S S S C N U Q I Z O E B B W
F A R M E R W A N T S A W I F E A Y E V P K C J L V A F F S
B T F B F C V M F M Z R E F E F K S L L F D H K X L C O E Z
K J V W J B M D C O F I M M L A P A S G G O X S M P A M A Y
E S R O H E V O L O T Z B N F O F I G I U N K A I N P E S P
Q F K D M T Y M E W H N T A K S W U X E O W I T H M T A T I
D I A P E R M A T E S G X J U O N M B X V N K S R C A N A J
W B D W A W I V U Z V V K P U W X K O A F M S Q F M I E L O
Q M N N G M E R P F Z Q Z O U C H O X I Y S R T C D N Q L M
T W E P W N I A D C P M E D K Q L L H L O N Z T S D D H X J
D N V F V Y J K D U S X J G E H B S G T D O U C G T A R L O
B K T L H F V T A K O E G P I U Q W T F Q L P K G C T Y H W
U V I D D Q K L S K Y P D S J K S J R Y A Y J T F W E O O Y
```

gonorrhea,
friend and confidant!

23

WORD LADDER:
ANNOYING INTERNET THINGIES!

Make as many words as you can out of each Annoying Internet Thingie, changing only one of the letters each time. All words have to be real (and we will enforce this Very Important Rule via the microchip embedded in this book's spine, just in case you were planning on suggesting that BLUG is a word. It is not).

BLOG POOP

BOT	BLOG	MEME
BOP		
BOO		

DECODE THE TEENAGE SHORTHAND!

Are you above the age of fourteen? You probably don't know what any of the below mean, but trust us, that's a good thing. The alternative would be that you have wayyy too much time on your hands.

DILLIGAS: _____

SSDD: _____

STBY: _____

RTFM: _____

IANAL: _____

IANAD: _____

IOKIYAR: _____

ELI5: _____

NIFOC: _____

BTDTGTTSWIO: _____

ICBINB: _____

THINGS THE INTERNET RUINED

hairflip

your ability to show off your
knowledge of obscure trivia, because
BuzzFeed does that now

your ability to eat fast
food in ignorant bliss

high school reunions,
because we already know
Carol is so proud of her kids

privacy

the dream of growing
up and working at Empire Records

bar fights, because you
can just have them
on Twitter

Journal:

Also these things, ugh:

PUT MARK ZUCKERBERG IN HIS NATURAL HABITAT!

Where do you want to see The Zuck go? Draw his natural habitat around him!

TURN THIS STICK FIGURE INTO A CELEBRITY YOU KNOW TOO MUCH ABOUT

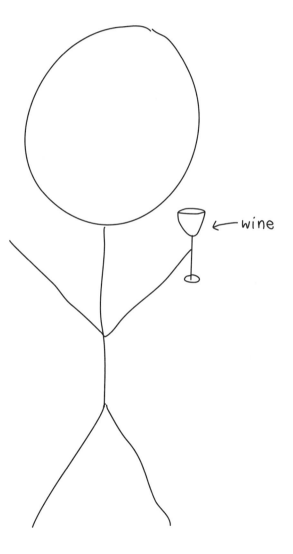

← wine

CUT OUT THE OFFENSIVE SCREEN TIME APP AND DESTROY IT

9:41

‹ Screen Time

| Today | Last 7 Days |

Tom's iPhone

SCREEN TIME Today at 9:41 PM

6h 45m ⬆ 22m above average

12 AM 6 AM 12 PM 6 PM

Social Networking Entertainment Productivity
5h 13m 50m 18m

LIMITS

Social Networking 9 hr ›

MOST USED SHOW CATEGORIES

f Facebook
 666m ›

▶ YouTube
 69m ›

📷 Instagram
 28m ›

💬 Messages
 23m ›

PAGE
INTENTIONALLY
LEFT
BLANK

WELCOME TO THE APOCALYPSE

32

FOLLOW YOUR SALARY THROUGH THE MAZE AND INTO JEFF BEZOS'S POCKET!

AVOID THE DASH BUTTONS YOUR CHILD WILL ACCIDENTALLY USE TO ORDER SEVENTEEN GALLONS OF LAUNDRY DETERGENT! FASHION BARRETTES! A FORTY-SEVEN-PACK OF WHITE T-SHIRTS FROM MAINLAND CHINA! FANCY WATER! A TUBSHROOM (TRUST US, IT'S A THING)!

30 THINGS THAT ARE MORE IMPORTANT THAN HOW MANY FOLLOWERS YOU HAVE

OMGGGGG your Hilarious Dad Jokes Instagram account hit 1,000 followers! That's so exciting! And is going to have a meaningful impact on your life because . . .

. . .

. . .

Oh, wait.

Take a moment to focus on these things instead, because they're what really make the world go 'round. Circle all your personal must-haves (and, fine, cross out the ones that don't do it for you personally).

1. Social justice
2. Peanut butter
3. Friends who let you use their HBO GO passwords
4. Caffeine
5. First kisses
6. The Westminster dog show
7. Math skills
8. Lexapro
9. Hot sauce
10. Health insurance
11. Grandparents
12. The smell of Hawaiian Tropic sunscreen
13. Adult gymnastics classes
14. Good lighting
15. Lip Smackers
16. Really great sweatpants
17. Dance parties for one
18. Public libraries
19. Rainy days with nothing to do
20. Clean water for everyone

This puppy = more important

21. A good, solid cry
22. Your health
23. Self-care
24. How much Carol in HR is getting paid, because if it's more than you that is BULLSHIT
25. Salad bar sneeze guards
26. Getting into the ocean as often as you can
27. Kittens with those adorable folded-down ears
28. Naps
29. Making kids laugh
30 Pie

Journal:

How could we have forgotten these?!

BUILD YOUR OWN

stfu

omg

LOL

BUZZFEED HEADLINE!

	FIRST LETTER OF YOUR FIRST NAME	FIRST LETTER OF YOUR FAVORITE WEBSITE	FIRST LETTER OF YOUR FAVORITE BRAND
A	50 New Emojis	You Can Buy on Amazon Right Now	and I Am Not Okay
B	20 Cutest Animals	All Celebrities Hate	and It Is Awesome Sauce
C	9 Celebrity Tweets	You Need to Know about	and It Is Lit
D	17 Justin Bieber Exes	That Will Blow Your Mind	and I Cannot Even
E	14 Relatable AF Moms	You Can Buy on Amazon Right Now	and Here Is Why
F	10 Shirtless Celebs	That Will Haunt You	and I Am Crying
G	15 Chocolate Cakes	You Can Buy on Amazon Right Now	and Is This Real Life?
H	19 Insane Challenges	Only People Born in the '80s Will Remember	and It's Literally Insane
I	8 Instant Pot Dinners	Only People Born in the '90s Will Remember	and I Am Dead
J	22 Awkward Exchanges	That You Have to See to Believe	and I Honestly Can't

K	40 Drunk Texts	Only Midwesterners Know	and What Even Is It?
L	10 Hilarious Grandparents	You Can Buy on Amazon Right Now	and It's Legit AF
M	30 Things Gen Xers Did	That Totally Nailed It	and There's an App for That
N	35 Best Clapbacks	That Will Tell You Everything You Need to Know about Yourself	and It Is Giving Me Life
O	18 Sandwiches	That Are TDF	and I Be Like
P	10 Disney Princesses	You'll Never Unsee	and Jesus Take the Wheel
Q	50 "Which Celebrity Are You Most Like?" Quizzes	You Can Buy on Amazon Right Now	and I Can't Feel My Face
R	7 Life Hacks	You'll Never Believe Are under $10	and I Don't Even Know What Day It Is Right Now
S	20 OTT Gifts	You Won't Ever Know How You Lived without	and It's EVERYTHING
T	40 Total Game Changers	You Can Buy on Amazon Right Now	and It's a Mood
U	10 Insane Emojis	You Need in Your Life	and I'm Trying to Can and Literally Can't
V	5 Cher Memes	You Never Knew Existed	and You Need to Stop What You're Doing Right Now
W	15 Unbelievable Movie Mistakes	You Can Buy on Amazon Right Now	and Who Even Am I?
X	100 Celebrity Smackdowns	You Will Never Unsee	and What Day Is It Even?
Y	1,000 Burning Man Photos	That'll Straight up Shock You	and I Am Slain
Z	10,000 Products	You Can Buy on Amazon Right Now	and OMG Consumerism!!!

YOUR WI-FI NEEDS A NEW NAME

Why name your Wi-Fi something reasonable, when it presents such an opportunity for comedy gold?

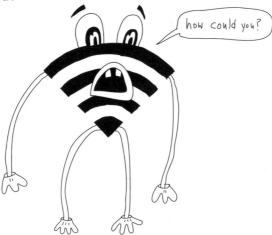

how could you?

Some suggestions:

Loading . . .
Hello My Name Is
No Devices Found
virus.exe
Skynet
Other
Mom Use This One

WI-FI NAME GENERATOR

Pair your favorite modifier with your favorite noun.

Aggressive	Kitty
Vicious	Investor
Libidinous	Corn
Vile	Newt
Profligate	Party
Litigious	Tailpipe
Vacillating	Psychic
Janky	Tuchis
Useless	Lettuce
Famous	Gluten
Twinkly	Didgeridoo
Cantankerous	Kahuna

DRAW (AND COLOR IN) YOUR HILARIOUS NEW WI-FI NAME AND PASSWORD

Then tear out this page and hang it on the wall so when your guests ask for your Wi-Fi info you can point them toward the framed—or, whatever, "framed"—work of art.

PAGE
INTENTIONALLY
LEFT
BLANK

40

JUST A PRETTY FLOWER

Go outside and find one.

Draw it.

9 PRODUCTS ON AMAZON YOU DO NOT NEED TO BUY*

Yes, even though you have Prime.

LIVE LADYBUGS
*Really into the idea of acquiring 1,500 incredibly creepy** bug-pets? Amazon can make that dream happen.*

FINGER HANDS FOR YOUR FINGER HANDS
In case you've always dreamt of high-fiving twenty-five people all at once.

WINE FOR CATS
Made with beets or something, this product is guaranteed to make Socks knead your face at three a.m., because that's what cats do when they're drunk. (Allegedly.)

A BALL SACK, FOR YOUR BALLS
Golf balls, guys. Golf balls.

A CHAMPAGNE FUNNEL
For when you want to slam back some Dom, yo.

A T-SHIRT COMPLETELY COVERED WITH PAULY SHORE'S FACE
This is a very specific item for a very specific type of person. But for that very specific type of person, you have just located the gift of the century. Also, hi, perfect first-date outfit!

*These are all products that Amazon really sells. And upon further consideration, there may be a few you actually do need. Go ahead and circle the ones that are already in your cart.

**To those who argue that ladybugs are, in fact, adorable: Check the underside of their wings, please. See that diaphanous thing that looks like a layer of dead (but still moving) cuticle skin? Right.

THE "GOTTA GO" PORTABLE BATHROOM CAPE

So subtle. So discreet. Nothing to see here!

A WALL DECAL FEATURING EXACTLY ONE HALF OF AN ASIAN BUSINESSMAN

The ideal finishing touch for any living space.

A SEE-THROUGH GUMMY BEAR ANATOMY PUZZLE

No gummy bears were encased in plastic and left to die a slow, excruciating death during the making of this toy. Probably.

FINE, IT'S NOT ALL BAD

FINE, IT'S NOT ALL BAD

The fact that technology is rapidly — like speed-of-light style — outpacing our capacity to responsibly handle that technology is stressful, to say the least. (Seriously, give humanity A Nice New Thing and we will quickly show you how to use it for porn and/or trolling.)

But for all that people go on and on about The Evils of the Digital Age (and write activity books about the profundity of our collective need to unplug every so often, hi), the Internet has also made incredible strides in terms of our ability to connect with individuals all over the world, access previously unthinkable quantities of information, and come together across cultural, social, and geographical lines to work for change. Children can use technology to obtain educational opportunities that would have been wholly unavailable just a few years ago. Families across the globe can keep in touch daily, and even see one another, face-to-face. You can even meet your future life partner while sitting on the toilet (see page 14)! Amazing.

Best of all, the Internet has made it possible for you to spend six hours watching videos of baby sloths being all baby slothlike.

And that, friends? That is a beautiful thing.

MIRACULOUS THINGS THE DIGITAL AGE HAS GIVEN US

On August 23, 1991—a day later dubbed "Internaut Day"—the creature that would one day give us endless opportunities to watch total strangers do the "Single Ladies" dance was born, and the world changed forever.

Here are some good things that the Internet gave us, thereby making our world just a little bit better:

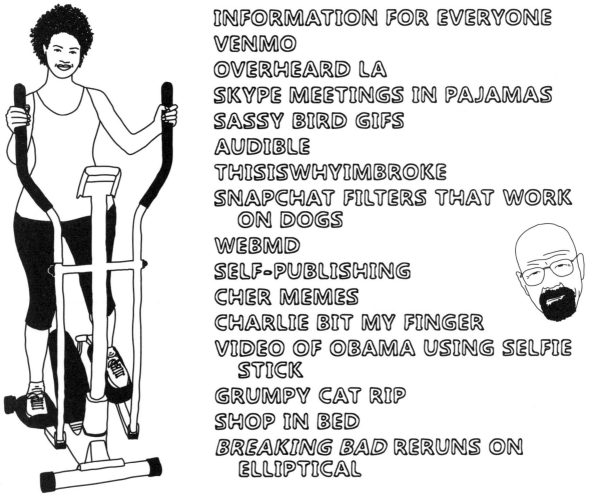

INFORMATION FOR EVERYONE
VENMO
OVERHEARD LA
SKYPE MEETINGS IN PAJAMAS
SASSY BIRD GIFS
AUDIBLE
THISISWHYIMBROKE
SNAPCHAT FILTERS THAT WORK
 ON DOGS
WEBMD
SELF-PUBLISHING
CHER MEMES
CHARLIE BIT MY FINGER
VIDEO OF OBAMA USING SELFIE
 STICK
GRUMPY CAT RIP
SHOP IN BED
BREAKING BAD RERUNS ON
 ELLIPTICAL

PLEASE CHER

```
W G A U B U M L D L X A H V M M S L J T Y Q L D P P S V W K
G W R B M Q I H I V X N Y Z K E N T W Y I I I E Z D L E R C
S K Y P E M E E T I N G S I N P A J A M A S N T K Y B F C I
Y S R K A S I B V R V S S P F C D R A E Z O K H G M P L Y T
I O H T G C Y C N V L L W L R V X L L X Y Y K I D H L H N S
S X U T K G C H P I C W K S P J D Z U R F H E S U R U I N E
D Q J B A W C R Y C V H U V G R U I E A H Z X I D T L G E I
Q X V D D Q E N P J T M Y G A U P V D B L R D S T K Z Y H F
K N V M K V A N Q R O F Z E K E E Z X C X T G W N K D M Q L
S G O D N O K R O W T A H T S R E T L I F T A H C P A N S E
Y C H E R M E M E S G R D C O P A M C N I W X Y R P M D E S
N F H F I L O G L V E O Q F S D I U G D V B I I M I H E N G
P C A A Q J M T W V R E N E L X O R D T A L G M X F A B Q N
V L Q T R N I J O Z Y O L W L T X O T I F K J B B Y J N F I
V E M V H L Y S K W I F U C C T J Q S A B L Z R Z L C I T S
X C F O F E I W V T P Z U W T S D F V I C L V O X P S P C U
B J B M A P F E A U M Y L H U O E P P F J Y E K T B C O A A
C H T A H J X M B V H O K L H A N Q L S L I P E E E C H K M
I F B N A E R L A I K K Z Z K Y D J X O A V P M Q N M S M A
M U Q K X O I K J R T D S N D B H E I J W Y W O U J W N G B
J F I S F S K B M P C M J P N R Q X K W U P F C O R D A E O
V O Q N H J J D W F M U Y Z R U W A H C C I P V A G G C Z F
H A I I I O L E J I O T D F T R Q X G Q K U L E A Q A F Q O
V N N V Q R X V E D S D K F I L G H C K Y U A O T R T V U O
T G V E F G R D G J V L J H U N S F I G D R I B Y S S A S E
V W F N X X I V G N X Z M J D I G I Z V X F E G A W I Q I D
P J Y M L P R P F K G X Z V N M M E C V U L Z M H U M E N I
G U K O Q T D F A K F H H P U B M N R O L P R C L D S G F V
D U V J M U F K C Z P N Z Y I R U T I U K F B H E S O U O Z
L A C I T P I L L E N O S N U R E R D A B G N I K A E R B A
```

Note: You can make a case for many of the above being, to the contrary, quite bad (see: Information for everyone, which of course can also mean Misinformation for everyone!). But let's be optimists for a day.

COLOR IN THE SOOTHING APPLE GENIUS
WHO FIXED YOUR CRACKED SCREEN FOR FREE

THINGS THAT ARE REALLY WORTH GOOGLING

Search engines have become far, far too big a part of our daily life. But there are some things that really are worth The Google, and in fact may justify the existence of the Internet as a whole.

Don't ask questions. Just type these things into your search box, STAT.

- Competitive dog grooming

- The word "askew" (without the quotation marks). Look closely; it's amazing.

- Your hot neighbor's address on Google Earth (maybe they're naked!)

- Anything that would, had you been born prior to 1990, have required the use of an Encyclopedia Britannica

- "Do a barrel roll" (also without the quotation marks)

- "Atari Breakout" (no quotes) and click on image search

CELEBRITIES WHO AREN'T INTO SOCIAL MEDIA

There are cooler things than getting four hundred likes on that photo of your dog. For example, not caring whether the photo you took of your dog got four hundred likes. Unscramble the names of these celebs, who DGAF about what you think about their life choices.

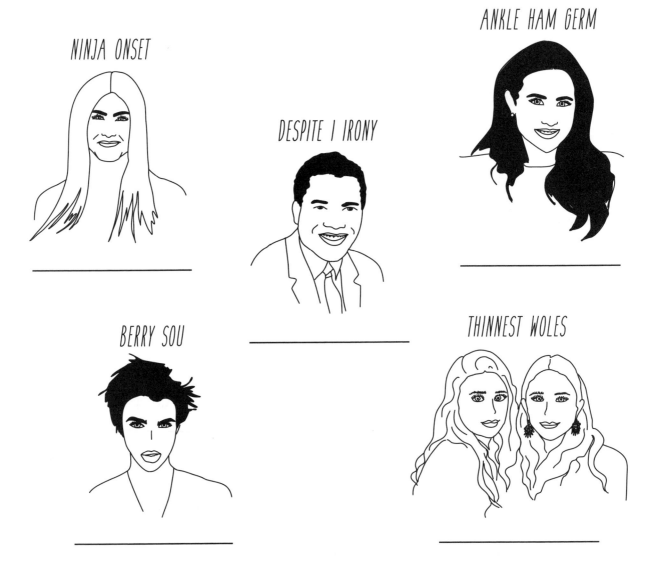

NINJA ONSET

ANKLE HAM GERM

DESPITE I IRONY

BERRY SOU

THINNEST WOLES

*Literally joined during the editing process for this book. Instagram eventually takes us all.

ANSWER KEY: L to R: Jen Aniston*, Meghan Markle, Sidney Poitier, Ruby Rose, Olsen Twins

52

I LIKE THESE PEOPLE SO MUCH

Fine, social media allows us to stay in regular touch with people we actually like. Draw the faces of four of your favorite humans.

Why I like him/her so very much:

Why I like him/her so very much:

Why I like him/her so very much:

Why I like him/her so very much:

THE DIGITAL GRAVEYARD

Have you ever used any of these? Congratulations, you are ancient. Do you currently use any of these? (If the answer is yes, please fill in the number of grandchildren you have here: _____.)

BETAMAX

ATARI

ANSWERING MACHINE

VHS

DVD

LANDLINE

TELEPHONE BOOTH

BEEPER

FAX MACHINE

DIAL-UP MODEM

PHONEBOOK

FLOPPY DISK

CASSETTE TAPE

WALKMAN

DISCMAN

MINIDISC PLAYER

SLIDE PROJECTOR

PRINT MEDIA

NOKIA

```
A E P C W C L J J N Z B E J V G W T Q G M N X V A N V X E P
Q N P R E B R X Y A D H S D C F V M J Q E Z A R T U Z N Q J
V O S A I A Y C A M E I P Q D H R V W M D W Z M D S I J D A
N F K W T N C T C C Z W Y H I F E Z I G O X M G K H N M D J
B I F H E E T G G S B E O T Q N N Y D B M E O Z C L T O D B
H S P E T R T M N I B O K D T F X Q G R P S V A F U A S D W
H Z E G T D I T E D H H U R E N N K G Q U I M Q T R S W D H
F P P K V P E N E D B Z A N P Z N U M E L X M F I Q M N Y S
V X Q G S H W R G S I N A S Y F M X R L A B W E L Z J J Q T
U A Z I R R V N Y M S A J L B P Z E Z F I I M A H V U T D P
C R O F E W R Z A J A A Q A H Q W E Q M D I N T O P H E V Q
I A H P H U W G Z F M C C D L Q T B W B N D R R W V K L H P
B H E A G X O B V L V C H L N R L Z L I L S I N K L G E S L
S E N M W S Z V N Z X R I M R I B D I H I J H C T Q P C B
B X I U Y U M C B Q N L Q F N F O I N C N M F V S D C H D D
Z G L V C P U C O M L L Z Z W E S E R A Y A P I E Q S O E Y
L I L B X W M D Y Z R N M N O C G D I F N E H A Y D Y N G C
X A M A T E B L D G H K X L P Q V N K S Z W O A B O W E D P
N H A V R T K S Z X T H Q L D R B A C O C A N Z Q C Q B N C
T V S O L O L X C C Q Y A H T K Y S L P V V E Z P B Q O J I
M X H M N P A B S L M Y E J D U N Y O X O N B Y F D L O P R
V K X J Y M P V K C E G S V I U Y L U L Y W O S N R D T V P
C Y R O T C E J O R P E D I L S A T A R I J O K J E B H J M
O X X B U P W E K C S T L T W Q I U P U W P K K I A J P D V
H Y T I C B F R Z S Q S K C P Q N L W E W O H Z N A V X Z G
O H N C F F D A G S C E B X W V C R A G M D H C N O T T T O
Q J F N B N T C A X W E W J O A U F F L O P P Y D I S K N U
Q Q U X A N D D T M H S D D Z S D Q N P F G I I R B G G C T
S C S F M Q R U V Q V H P Q F H O J L J B U P A A I B O W O
Y F F A O S D G C W L B T S N H A M W L A F T Y M J Z H O X
```

LITTLE LIFE ANNOYANCES THAT DIGITAL ADVANCEMENTS FIXED

- Waiting until the album is released to hear the single
- Waiting a week to see what happens next on your favorite show
- Having to commit to meeting someone at the time and place you promised to meet them, because otherwise they'd be scared you died
- Having to buy things like vibrators from actual human beings
- Having to remember phone numbers*
- Having to own a TI-83
- Finding your car in a crowded parking lot (hit that panic button, yo)
- Children on planes
- Children in cars
- Children on lines
- Having children, generally
- That massive stack of restaurant menus in your junk drawer

Pop Quiz: Your childhood phone number (aka the only one you still know): _____

*Still comes in handy for "one phone call" purposes in the case of unexpected imprisonment.

THE WORST

Some things are best left on the garbage dump of history. This is one of them.

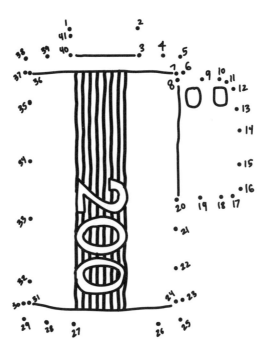

Remember how it used to work? Here's a play-by-play, in case you're too young or too old to recall.

1. Go to store.
2. Buy film.
3. Return to store.
4. Bring in film.
5. Return to store again.
6. Pick up film. Pay lots of money for it.
7. Discover that you took twenty-four shots of your niece's ice-skating competition in which she looks like a blurry rice grain.

REALITY CHECK:
WE LIVED WITHOUT THESE THINGS FOR A LOOOONG TIME

When did these so-called Important Things show up? Put them in the correct order of evolution.

Lucy

DoorDash

Jesus

Elvis

Home computer

Homo erectus

American Revolution

Agriculture

Fax machine

iPhone

Gutenberg printing press

Space Invaders

Homo sapiens

COLOR IN THESE OLD THINGS

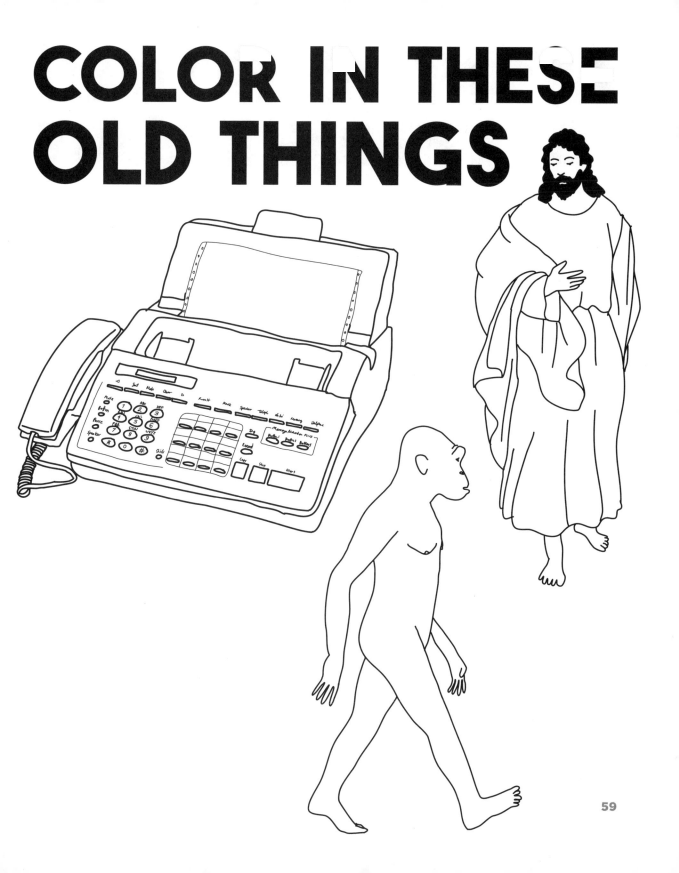

A TIME CAPSULE
FOR THE DIGITAL AGE

One of the ways technology has changed how we live: We not only use photography to document the things that matter to us—our partner, our pet, a beautiful view—but also as a tool with which to navigate the world. Photographs have become useful in a way they never were before—and in those photos we take only for ourselves, we capture the real moments that make up our un-curated lives.

For this time capsule, go ahead and de-detox for a moment. Pick up your phone and find the following images, then save them in a folder. Add to them over time. Remember that the memories often lie in between the moments.

- A photo of your face that you never intended anyone to see
- A photo of a receipt
- A photo of a parking spot you took so you could remember where you parked
- A screenshot of a text conversation
- A screenshot of this week's calendar
- A photo you took by accident
- An unattractive photo of your food
- A photo your best friend sent you
- A photo a family member sent you
- A photo of something you were thinking about buying
- A photo you thought about posting—but then posted a different version instead

a photo of the illustrator
making a face at the dentist's

the illustrator considered
buying these "wings"

MAZE:
GET PAC-MAN SOME CAKE

When the digital age gets you down, just remember: Computers brought us Pac-People.

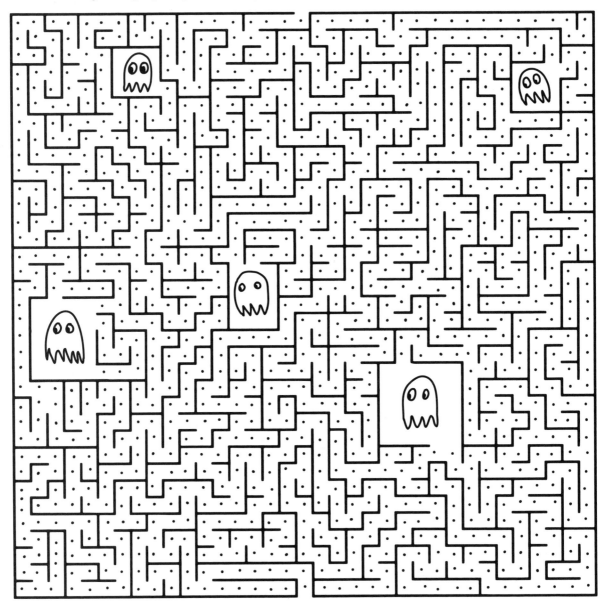

COLOR IN THIS RELIC FROM AN ANCIENT TIME

THINGS THAT ARE WORSE FOR KIDS THAN SCREEN TIME

We've all heard the statistics: Excessive screen time from a young age causes everything from eye-strain to attention problems to obesity. But there are worse things! So many worse things. Things that make kids super sad. For example:

food touched other food

forced to wear a coat

bedtime

best ice-Cream flavor is sold out

no more Cheerios

EMAIL, CIRCA 1150

TRUE OR FALSE: OBSCURE FACTS!

Which of these tidbits are real, and thus can be used to blow your friends' minds?

China has treatment camps for Internet addicts. **T/F**

The first image uploaded to the World Wide Web was of an all-female pop band called Les Horribles Cernettes. **T/F**

The first webcam was created to monitor a coffeepot. **T/F**

"Gangnam Style" is still one of the most-watched videos of all time. **T/F**

The majority of Internet traffic is generated by bots and malware, not humans. **T/F**

You can still view the world's very first website (info.cern.ch). **T/F**

If you translate the moving electrons that make up the Internet into grams, you get about 50. The Internet, in other words, weighs about as much as a large strawberry. **T/F**

The first video ever uploaded to YouTube was titled "Me at the zoo." **T/F**

In 2006, the most-viewed profile on MySpace was Tila Tequila's. **T/F**

In 2013, the most commonly searched question beginning with "What is" was "What is twerking?" **T/F**

The original use of the Internet—pre–World Wide Web—was to trade lo-fi porn referred to as "ASCII prOn." **T/F**

ANSWER KEY: These are all true. And if the one about "Gangnam Style" makes you question the very fabric of reality . . . well, we're right there with you.

IDENTIFY THE MOVIES THAT WOULD NEVER HAVE EXISTED IF NOT FOR THE INTERNET

HOW TO:
DIY YOUR OWN STRAIGHTJACKET

Current federal law has made it extremely difficult to pick up a for-real straightjacket (which, let's be honest, is very literally the only creation on God's green earth capable of keeping you from checking your ex's Instastories), so if you want one, you'll have to make it yourself.

. . . Oh, wait. Never mind. You can buy one at Walmart.

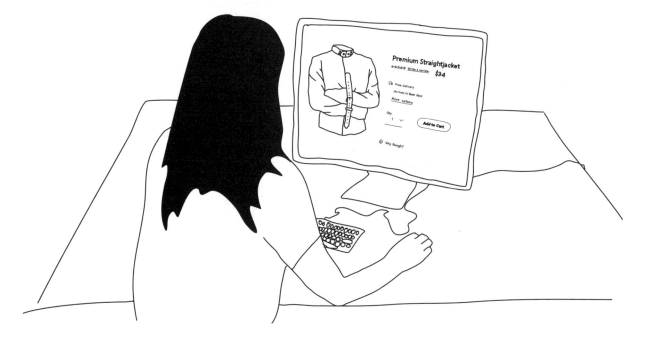

JUST ANOTHER DIGITAL DAY

Hand this page over to a partner, who will prompt you for each blank, then read your epic creation out loud.

When I woke up this morning, the first thing I did was check my _____.
 device

I went onto _____ and discovered that _____ ate some
 social media channel name of friend

_____ and feels really _____ about it. I also found out that
 food emotion

_____ tattooed a/n _____ on his/her _____ and
family member object body part

that _____ ran away to _____ with _____.
 celebrity place another celebrity

All of this made me feel very _____.
 emotion

When I got to work, I turned on my _____ and started to
 device

_____. Then I went on _____ and watched a video about
 verb social media channel

_____, then another one about how to make _____ from
 activity noun, plural

scratch. It was so _____ I could hardly stand it. I needed some new
 adjective

_____, so I clicked over to _____. Ooh, a _____!
 noun, plural shopping website noun

I paid _____ for it right away. I can't wait for it to arrive so I can
 number of dollars

_____ with it.
 verb

After work, I texted _____ to see if s/he wanted to _____,
 person verb

or maybe _____. S/he texted back s/he had to _____ instead,
 verb verb

so I went home, ordered some _____ from _____, and settled in
 food website

for an evening of watching _____ _____ in the
 animal, plural verb

_____. Right before I fell asleep I checked _____ and found out
 place social media feed

that _____ is being sponsored by _____ and really thinks I
 social media personality company

should buy their _____. It's already in my basket.
 noun, plural

TOP 5
REASONS I LOVE THE INTERNET

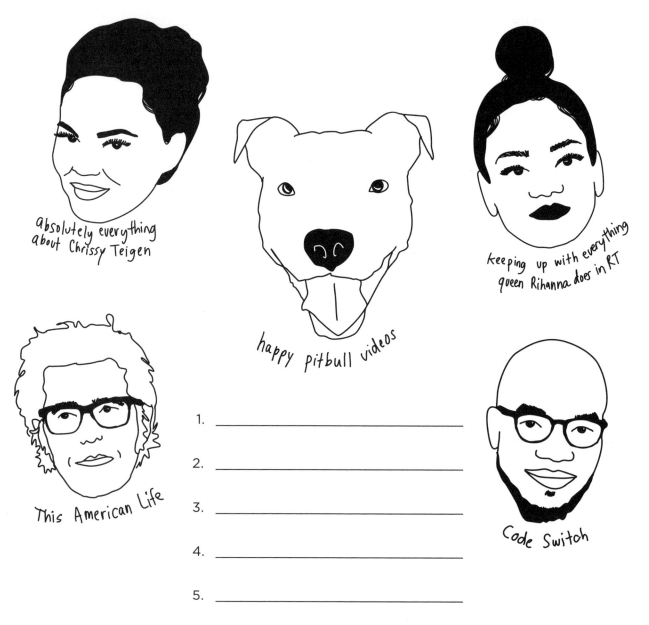

absolutely everything about Chrissy Teigen

happy pitbull videos

keeping up with everything queen Rihanna does in RT

This American Life

Code Switch

1. _____

2. _____

3. _____

4. _____

5. _____

good things

One of the very best things about the online world is that it offers you endless opportunities to find communities of people who can serve as mentors, teachers, coconspirators, or simply friends who make you feel less alone. Being trapped in the house with a newborn or stuck in the hospital with a chronic condition can be incredibly isolating—but finding allies in surprising places can make many hard things more tolerable and bring all kinds of unexpected joy.

My favorite person to follow online: _____

My favorite online community: _____

My favorite IRL relationship that began online: _____

The blog post/podcast that I keep coming back to: _____

The website that has helped me the most: _____

MATCH THE CELEBRITY TO THE DUMB THING THEY DID A DECADE AGO AND WILL NEVER LIVE DOWN BECAUSE INTERNET EVIDENCE DOESN'T DIE

1. Miley Cyrus: _____

2. Reese Witherspoon: _____

3. Kendall Jenner: _____

4. Ariana Grande: _____

5. Tom Cruise: _____

6. Winona Ryder: _____

7. Ashton Kutcher: _____

8. Mel Gibson: _____

9. Britney Spears: _____

Sorry, Kendall

(a) Pulled the "Do you know who I am?" card with cops

(b) Cheated on spouse. In a hot tub. On their wedding anniversary.

(c) Shoplifted at Saks

(d) Jumped on Oprah's couch

(e) Called a cop "Sugar tits"

(f) Strolled barefoot into a gas station bathroom

(g) Twerked on Robin Thicke

(h) Licked an unpurchased donut

(i) Brought peace to America . . . with Pepsi

CAMP DIGITAL DETOX

CAMP
DIGITAL DETOX

Maybe you went to summer camp. Or maybe you spent your summer vacations alone in your bedroom with your back against a fan and your nose pressed into a *Betty and Veronica Double Digest* (just us?). Either way, you certainly have some concept of what summer camp is like.

Quick word association time!

Bunk bed: _____

"Kumbaya": _____

Sing-alongs, generally: _____

Crafting: _____

S'mores: _____

Sleeping bag: _____

Counselor: _____

Rowboats: _____

The Big Dance: _____

What we'd like to do in this section is take you back to those halcyon days, whether you experienced them IRL or not—except this time, let's skip the mosquitoes and the crap food and the kid from Schnecksville, Pennsylvania, who tried to kiss you while slow-dancing to Shania Twain but accidentally licked your ear instead.

Macaroni necklaces for everyone!

THE DIGITAL DETOX: A STEP-BY-STEP GUIDE

There is a 99.99 percent chance that your phone is sitting next to you right now, if not physically in your hand. Which makes sense—all those notification ding-ding-dings (I have an email! Somebody is thinking about me! Somebody likes me!) release dopamine, and you know what our brain likes?

Dopamine.

Alas, our collective technology addiction—and it *is* an addiction, by every technical definition of the word—comes with a host of side effects, like social isolation, decreased attention span, sleep problems, depression, and the belief that yes, you really *do* need to see each and every one of the 316 photographs your cousin posted in her Carnival Cruise Honeymoon album on Facebook.

No one's saying you need to drop off the grid—being connected is, to some extent, a requirement of modern-day life—but there are entirely manageable techniques you can use if you're feeling like your screen habit needs to dial down.

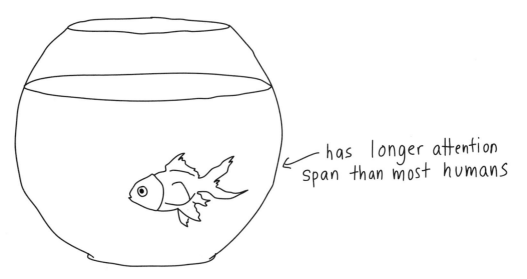

has longer attention span than most humans

Take It Slow: As those helpful Chantix commercials remind us oh so often, going completely cold turkey is a recipe for disaster. It's also unrealistic. Start with mini-breaks instead—fifteen minutes with your phone on airplane mode, an entire dinner without a single inbox check—see how you feel, and proceed accordingly.

Buy an Alarm Clock: When you take your phone to bed, you are literally inviting the world to annoy you with its needs and alerts and pings and articles about "The jaw-dropping 'nude bikini' that celebs CAN'T get enough of!" to say nothing about what having a screen right there next to you does to your sleep cycles (no need to google; the answer is "bad things"). Buy an alarm clock. Use it. Charge your phone in the living room. And then reunite with your device only once you've gone through your morning routine and are ready (or whatever, as ready as you can be) to deal with that damn bikini, because you know you want to see it.

Get the Newspaper Delivered: Whatever your personal leanings, we can all agree that the news is a little extra these days. Pick your favorite newspaper and get your fix the old-school way: By wrestling with pages the size of a toddler over your morning cup of coffee. When you're done, you're done. (Until tomorrow.)

Disable Push Alerts: There are some things you need to know about right away: Whether, for example, your child swallowed a Pez dispenser instead of just the Pez. Other things— like whether the "photographer" on Hinge liked the photo of your new tattoo or visual evidence of how the latest Jenner celebrated his or her birthday (spoiler: It was expensive)—can wait a hot minute.

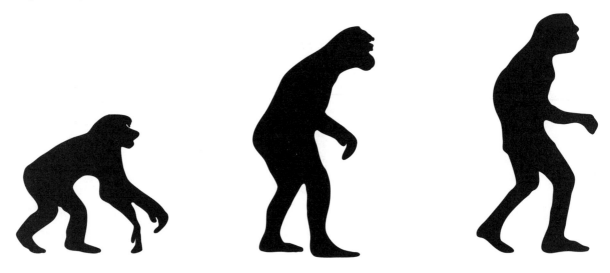

One Screen at a Time Plz: When was the last time you watched a movie without simultaneously uploading photos of yourself watching the movie (cute socks, btw), scrolling through some feed or another, or checking (and rechecking) your email to see if Something Important happened? It's much more fun the old-fashioned way, where you get to actually, you know, watch the damn movie.

Use Airplane Mode Even When You're On the Ground: Are you exercising and listening to music? That's great! Do that. And just that. Having your phone on airplane mode lets you actually, you know, do the thing you're doing, instead of another thing.

Follow the Good, Unfollow the Bad: While you're at it, pick one (or more) social channels to ignore completely. Twitter, for example, can be summed up as "a very large room in which everyone is screaming at one another and nobody is listening." You do not need this.

Do It, Instead of Just Looking at It: Do you love following various #fitspo types? You should go for a run. Into weird, artsy feeds? Go look at some weird, artsy art at a museum. Do foodie blogs get you going? Make food! (Making food is better than looking at pictures of it because you get to eat it.) As a wise Bachelorette once said, "Do the damn thing."

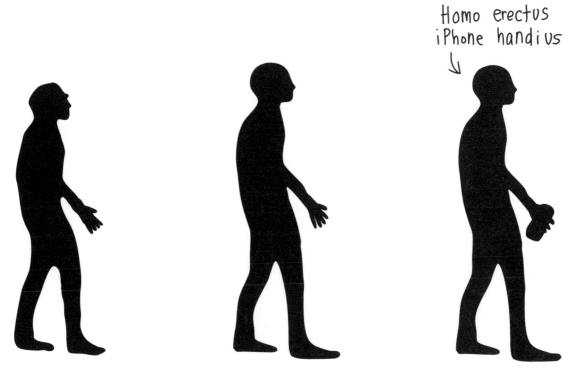

Homo erectus
iPhone handius
↓

RAINBOW CELERY.
WHY NOT?

You're not eight anymore, but that doesn't mean you can't get down with a super-cool science experiment. Just call us "Ms. Reid" and "Ms. Williams" and accept that this is a mandatory assignment.

Step 1: Put a bunch of mason jars on your windowsill. Also, have a bunch of mason jars.

Step 2: Fill them halfway with water.

Step 3: Put a few drops of food coloring in each one, until the color is bright and saturated.

you'll have to use your imagination →

Step 4: Cut some celery and put one stalk in each jar, cut-side down.

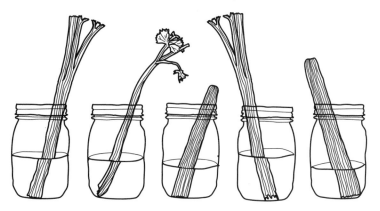

Step 5: Wait. Wait a long time. Practice this whole "patience" thing.

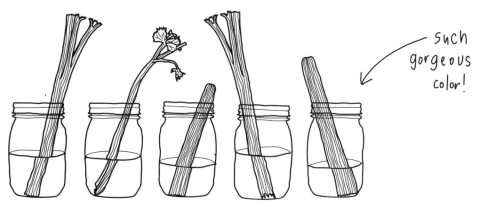

such gorgeous color!

Step 6: Get out your Encyclopedia Britannica from 1986 and look up "capillary action." If you google it, minus 5 points.

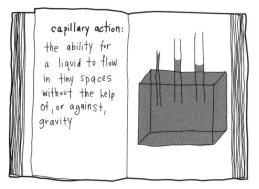

capillary action: the ability for a liquid to flow in tiny spaces without the help of, or against, gravity

Step 7: Achievements unlocked: Has rainbow celery, learned a science thing.

DRAW YOUR HAPPY PLACE (AND PUT YOURSELF IN IT)

MY MEMORIES, FOR POSTERITY

Because you are more than your status updates.

My very first memory: _____.

My favorite story about my first pet: _____.

My first celebrity crush, and how I expressed my undying love: _____

_____.

The first song I ever slow-danced to was _____.

I danced with _____,

which was _____.

My favorite vacation: _____.

My favorite thing I did there: _____

My favorite thing to do when I got to stay home

sick from school: _____.

One of the nicest rainy days ever was when I:

_____.

The food I legit couldn't get enough of when I

was a kid: _____.

When I close my eyes and think of lying in the

grass, this is where I am: _____

_____.

My favorite childhood TV shows:

1. _____

2. _____

3. _____

The best nap I ever took: _____

_____.

Even though I'm older now, I still believe in

_____.

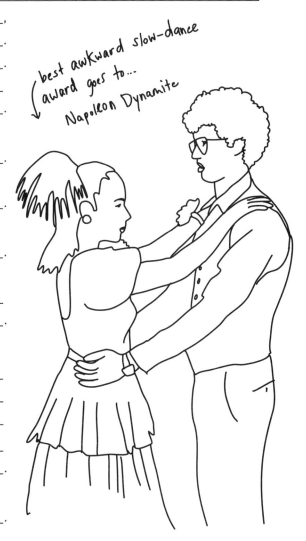

best awkward slow-dance
award goes to...
Napoleon Dynamite

BOOKS!
REMEMBER THOSE?

Here's why reading a book on paper is the best:

1. Books smell great, especially if they're new or from a library.

2. You can be dramatic about paper cuts.

3. Book covers are art, so they double as décor once you're done reading them.

4. You can hide papers and letters and things in the pages and then find them later.

5. You'll look way cooler on the subway than all the people with phones in their faces (everyone).

6. Finishing a wonderful book and pressing "Power Down" isn't nearly as satisfying.

CREATE YOUR OWN
COMPLETELY FABRICATED
CELEBRITY GOSSIP!

Hand this page over to a partner, who will prompt you for each blank, then read your epic creation out loud.

OMG you guys. I just opened up _____, and apparently
 social media channel

_____ went to _____ with _____, and when they
 celebrity place person

walked in _____ was there and s/he was _____. And THEN
 other celebrity verb ending in -ing

some _____ arrived and started _____ and poured some
 noun, plural verb ending in -ing

_____ all over _____, which was _____.
 liquid person adjective

And THEN, _____ walked in wearing a _____ on his/her
 other celebrity noun

_____, and ordered some _____, which he/she then put on
body part food

his/her _____. Then he/she ordered a _____ and tossed it at
 body part drink

_____, who _____, and then the whole place just
person verb, past tense

_____.
verb, past tense

I am so, so happy I know all these things. Thanks, Internet!

GET YOUR FACTS STRAIGHT!
(WITHOUT GOOGLING)

CENSORED

Circle the correct answer in each column.

1. Number of times a US president has been assassinated — 4 or 8?

2. Milligrams of caffeine in a cup of coffee — 95 or 9.5?

3. Novels by Joan Didion — 12 or 5?

4. Size of world's largest spider, in inches — 6 or 12?

5. Actual number of licks required to reach the center of a Tootsie Pop — 142.18 or 1,421.8?

6. Price of Napoleon Bonaparte's penis when it was sold at auction in the 1970s, in dollars — $30 or $3,000?

7. Number of sheep per person in the Falkland Islands — 153 or 53?

8. Number of dimples on a regulation golf ball — 36 or 336?

9. Average number of people who choke to death on ballpoint pens each year — 10 or 100?

10. Calories consumed when licking a stamp — 0.1 or 1?

11. Memory span of a goldfish, in seconds — 3 or .003?

12. Size of child that can fit inside a hippopotamus's mouth, in feet — 2 or 4?

13. Number of weeks it took to film the 1992 comedy *Wayne's World*　　　　2 or 4?

14. Percentage of photocopier system failures caused by people trying to photocopy their butts　　　　2.3% or 23%?

15. Percentage of people globally who have never made or received a phone call　　　　5% or 15%?

16. Amount of money, in dollars, that American Airlines saved in 1987 by removing one olive from each first-class salad　　　　$40,000 or $400?

17. Miles of blood vessels in the human body　　　　600 or 60,000?

18. Number of rolls of toilet paper the Pentagon uses per day　　　　636 or 2,240?

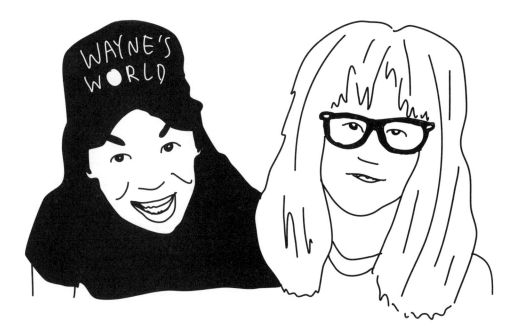

REDDIT:
THE GOOD PARTS

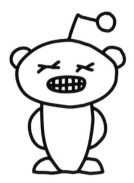

Yes, Reddit is the online home of all kinds of obscure and obsessive fandom, and it can be extremely creepy. But it also contains some really wonderful little corners where people band together over all things mildly infuriating and unexpectedly lovely. Here are a few of our favorites.

r/nonononoyes—Here you'll find clips of a bad thing (NO NO NO NO) *almost* happening, but then (YES!) danger is averted at the last possible second. It's like getting the adrenaline rush of a car crash without actually dying. Fun!

r/instant_regret—Bad breakup? How about a new haircut?! Want to stand next to a gold statue for a photo op? What if the statue is actually a mime?! . . . See where this is going?

r/aww—Just a bunch of stuff to make you say "aww." Instant mood lifter.

r/mildlyinfuriating—Arguably the world's greatest subreddit, this is a massive collection of things that are, as the name suggests, mildly infuriating. Check out the floor tiles that don't *quite* match up, or the sign with left-justified text *except for one line.* Advance apologies for the nightmares.

r/deadmalls—For any readers of this book born prior to 1985, this subreddit will immediately transport you back to the '80s malls of your youth, when purple and turquoise were totally kool, and life was just one big consumerist Solo cup.

HOW TO:
WRITE CASUAL CALLIGRAPHY

You, too, can have one of those giant scripted signs above your kitchen counter that reads "Grateful for my family" or "Bread." Here are some calligraphy practice pages to get you started. Then just transfer to a giant wooden board, hang up, and revel in your inner Joanna Gaines.

Let's practice. Trace the letters below with a calligraphy pen (or whatever else you have around).

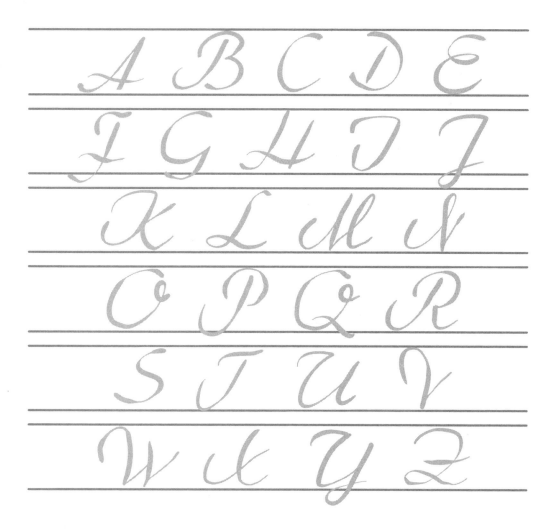

a b c d e f

g h i j k l m

n o p q r s t

u v w x y z

Now, write whatever you want!

Not sure where to start? Try one of these slogans:

- Oh gravity, thou art a heartless bitch.
- Never gonna give you up, never gonna let you down.
- Chipmunks are like cigarettes: They're not dangerous until you put one in your mouth and light it on fire.
- I am unable to quit, as I am currently too legit.
- If you can't say something nice, say something clever but devastating.
- Fututus et mori en igni
- It's not hoarding if your shit is cool.
- How much can't could a white girl can't if a white girl literally couldn't even?

5 THINGS TO DO FIRST THING IN THE MORNING BESIDES LOOK AT YOUR PHONE

We all do it: The alarm rings and our hand shoots out like a heat-seeking missile, just desperate *to find out whether the college roommate we haven't spoken to in six years posted her #ootd (she did). Tomorrow morning, try doing one (or all!) of these instead.*

1. DREAM JOURNAL.

How else will you be able to analyze that dream about Carol from HR turning into Thanos from *Guardians of the Galaxy*, and then pulling out all your teeth, one at a time?*

2. MASTURBATE.

Or meditate. Both are excellent ways to start your day, so the choice is yours.

3. GO TO WORK EARLY.

Benjamin Franklin, Barack and Michelle Obama, Charles Darwin, Indra Nooyi: All made it a habit to wake up at sunrise and get cracking on their day. And studies show that we are at our most productive first thing in the morning, so there you go. Drop your Instagram habit, pick up a promotion. *Boom.*

4. MAKE A RIDICULOUS BREAKFAST (AND DON'T PHOTOGRAPH IT).

Cloud eggs, avocado toast, a dragonfruit smoothie bowl. Gorgeous. Share it with *no one.*

5. THINK ABOUT WHAT YOU'RE GRATEFUL FOR.

Actually, it's kinda nice.

*This dream means that you do not like Carol.

DRAW MORE TATTOOS ON MEDITATING GUY

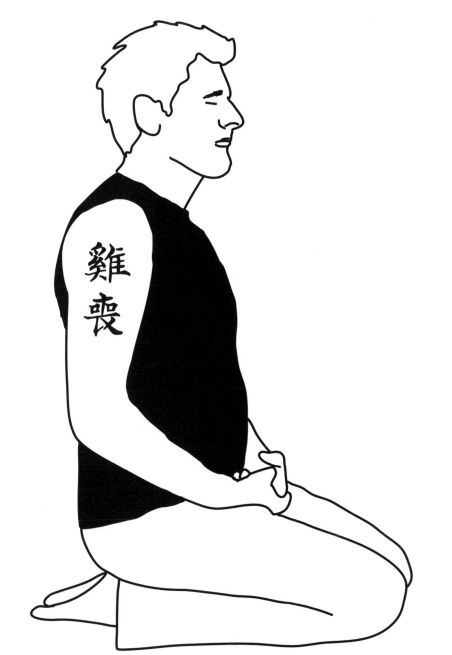

CRAFT WITH YOUR OBSOLETE CORDS!

*What to do with the sixty or seventy perfectly good cords that Apple has forced you to purchase over the years thanks to *completely necessary* updates to their . . . cords? Try these sweet crafts on your next rainy afternoon.*

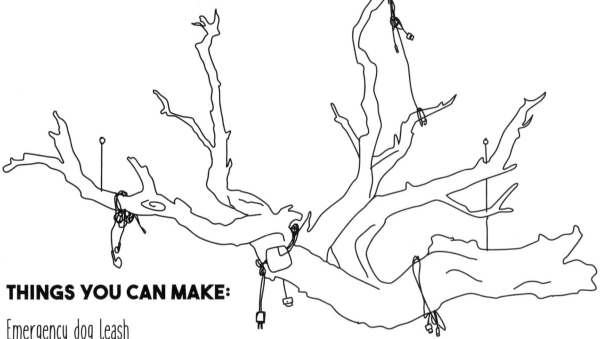

THINGS YOU CAN MAKE:

Emergency dog leash

Woven rope to tie together all your other soon-to-be obsolete cords

Knot practice for the next time you sail somewhere and are put in charge of making knots

Sad wreath

Driftwood accessories

Modern art: Put some washi tape on them, mold them into the shape of a cactus, and put that shit on Pinterest

SLIP 'N SLIDE
YOUR WAY TO PURE, CHILDLIKE JOY

*Avoid pop-up ads telling you that you need Things!
The constant and ongoing judgment of your peers!
MLM schemes involving yoga pants!*

Bonus: Go buy a for-real Slip 'N Slide and then use it. You will not be sorry.

Check one:

❏ Bought a Slip 'N Slide because my activity book told me to, and am now, oh god, so happy.

❏ Checked Facebook instead. Goddammit.

PASTORAL LANDSCAPE

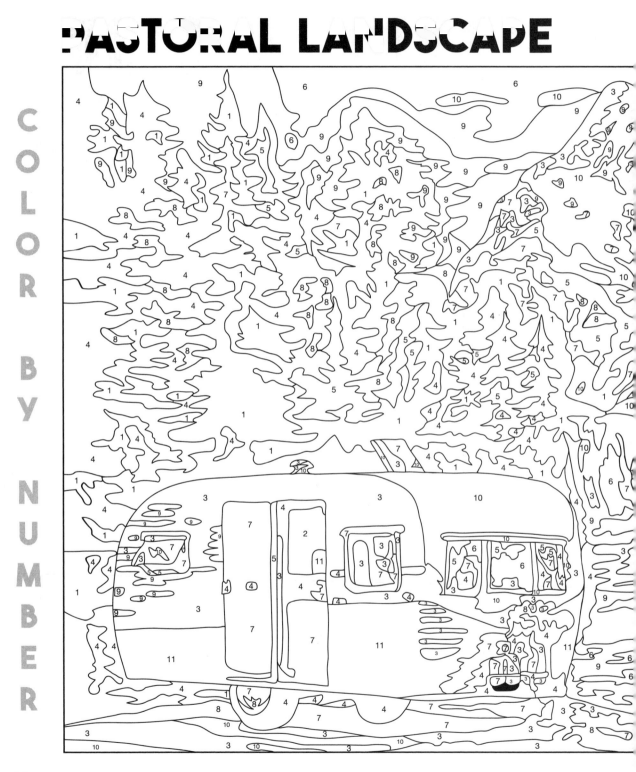

Go on: Channel that inner Bob Ross.

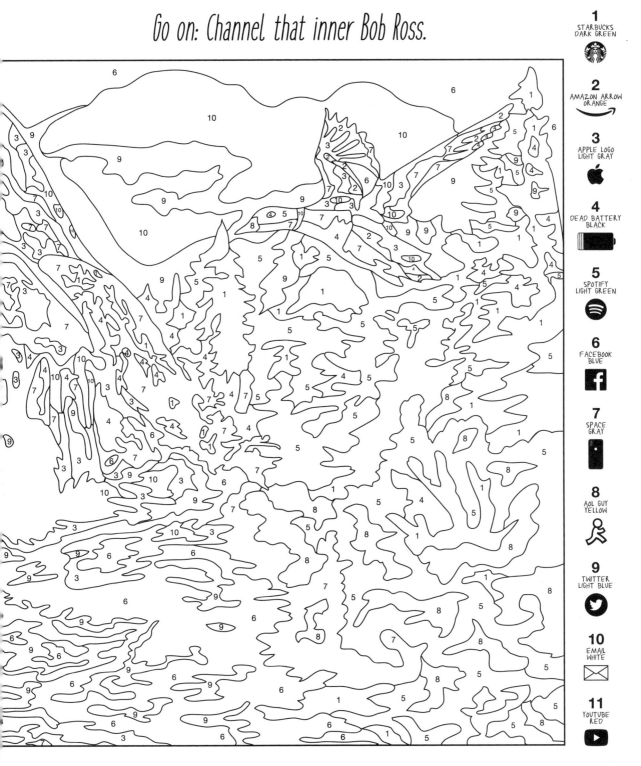

1 STARBUCKS DARK GREEN

2 AMAZON ARROW ORANGE

3 APPLE LOGO LIGHT GRAY

4 DEAD BATTERY BLACK

5 SPOTIFY LIGHT GREEN

6 FACEBOOK BLUE

7 SPACE GRAY

8 AOL GUY YELLOW

9 TWITTER LIGHT BLUE

10 EMAIL WHITE

11 YOUTUBE RED

A PORTRAIT OF YOU MEDITATING WHILE DOING QUADRATIC EQUATIONS IN YOUR HEAD

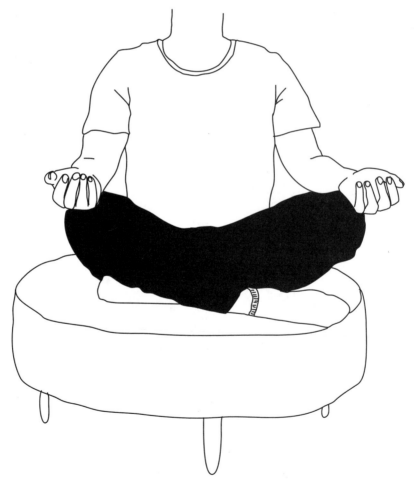

So peaceful. So present. So Zen.

HOW TO:
MAKE FINGER PUPPETS SO YOU CAN'T USE YOUR PHONE

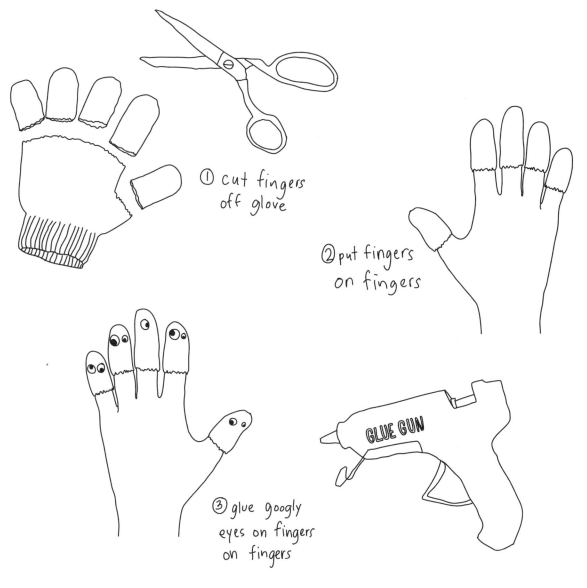

① cut fingers off glove

② put fingers on fingers

③ glue googly eyes on fingers on fingers

MATCH THE SONG TO ITS SINGER

Remember when songs used to be odes to brown-eyed girls and Stacy's mom? The digital age brought us ballads about selfies. #modernromance

1. Pocket Calculator	(a) Radiohead		
2. Text Me in the Morning	(b) Jamiroquai		
3. Technologic	(c) Neon Trees		
4. Startup Chime	(d) Trey Songz		
5. Ayo Technology	(e) The Buggles		
6. Video Killed the Radio Star	(f) 50 Cent		
7. Mr. Roboto	(g) The Chainsmokers		
8. Paranoid Android	(h) Kraftwerk		
9. 21st Century (Digital Boy)	(i) Brad Paisley		
10. Virtual Insanity	(j) Daft Punk		
11. Computer Age	(k) Neil Young		
12. SmartPhones	(l) Ladytron		
13. Online	(m) Bad Religion		
14. #SELFIE	(n) Styx		

These songs are also banned:

1. _____
2. _____
3. _____

VERY BORING FACTS ABOUT THE AUTHORS OF THIS BOOK

We are extremely famous. So extremely famous that we feel that you should be privy to some ~~fascinating~~ extremely average trivia about, well, us.

Match the fact to the extremely famous author.

JORDAN

ERIN

1. Gets heartburn from Diet Coke
2. Favorite color is yellow
3. Favorite food is salad
4. Hates drinking water
5. Not into nature
6. Has inflexible hamstrings
7. Very specific about mug size and weight
8. Has shitty cuticles
9. Hates washing pots and secretly believes they'll clean themselves if left alone for long enough
10. Not into cookies
11. Super grossed out by the Coca-Cola slurp-sound ad at the beginning of movies
12. Has a lazy eyebrow

Your turn! Write down five really boring things about yourself.

ANSWER KEY: Erin: 1–6; Jordan: 7–12

DIGITAL DETOX BINGO

made a decision without group texting	slept without phone next to head	phone turned off	unfollowed toxic people	took a long walk
looked up	did a thing and didn't post about it	meditated	deleted this channel _____	read an actual book
did a scavenger hunt	had a weird crafty moment	played a board game	self-reflected	read an actual newspaper
disabled push alerts	made a shitty Amazon purchase (oops)	planned a trip	deleted this app _____	used airplane mode (not on airplane)
discovered inner Bob Ross	turned ringer off	read an activity book (hi!)	danced alone for ten minutes	looked hot and didn't take a selfie

THE SOCK CHALLENGE

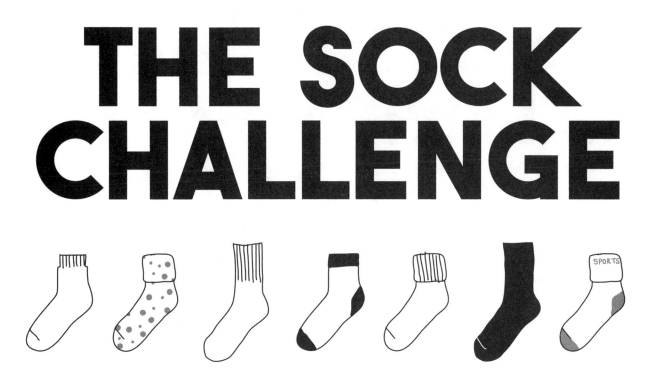

There are few things more likely to drive a person fully off the deep end than the complete and utter inability to find a pair of matched socks, despite the fact that there are 2,439 single socks right there in the drawer.

This simple exercise will make you feel so wonderful.

STEP ONE: Put your socks in a bag. Yes, all of them.

STEP TWO: Walk your bag of socks to a shelter or a clothing donation center. Donate it.

STEP THREE: Walk to a store that sells socks. Buy three bags of completely identical socks that can be worn everywhere, at all times.

STEP FOUR: Do not ever buy any socks other than that predetermined brand and style. No, not ever.

MATCHED SOCKS FOR ALL ETERNITY = HAPPINESS.

MATCH THE CRAZY CELEBRITY FACTS! (WITHOUT GOOGLING)

1. Was briefly a pimp (in France)
2. Got his first driving lesson from Paul Newman
3. Has a master's degree in chemical engineering
4. Real name is Reginald Dwight
5. Real name is Norma
6. Was a natural blond
7. Is a trained sniper
8. Has two extra nipples
9. Fired from Dunkin' Donuts for squirting jelly at a customer
10. Suffers from a condition called "stubby thumb"
11. Was once the mayor of Cincinnati
12. Father was a hit man
13. Middle name is Andrew
14. Is terrified of clowns
15. Named all five of his sons "George"
16. (Allegedly) slept with a ghost
17. Owns a body-shaped, hand-carved marble-and-onyx bathtub
18. Divorced all his wives when they were thirty-three
19. Has a tattoo reminding her to drink water (SMART)

(a) Elvis Presley
(b) James Lipton
(c) Dr. Ruth
(d) Elton John
(e) Madonna
(f) Jake Gyllenhaal
(g) George Foreman
(h) Jennifer Lawrence
(i) Woody Harrelson
(j) Michael J. Fox
(k) Tom Cruise
(l) Kesha
(m) Dolph Lundgren
(n) Jerry Springer
(o) Megan Fox
(p) Marilyn Monroe
(q) Johnny Depp
(r) Oprah
(s) Harry Styles

ANSWER KEY: 1. b; 2. f; 3. m; 4. d; 5. p; 6. a; 7. c; 8. s; 9. e; 10. o; 11. n; 12. i; 13. j; 14. q; 15. g; 16. l; 17. r; 18. k; 19. h

COLOR IN THE MANY NIPPLES OF ALTERNATE-UNIVERSE JOHNNY DEPP!

THOSE GAMES YOU PLAYED
WHEN YOU WERE A KID

Remember the joy of sitting down around a board game with your family and having a Lovely Old Time full of crackling fireplaces and cocoa? Remember how halfway through the game your sister would always cheat like SO F—ING OBVIOUSLY and then your dad would take all your hotels, which was RUDE, and your mom wouldn't even be paying attention so what's EVEN THE POINT, you guys?

#Memories

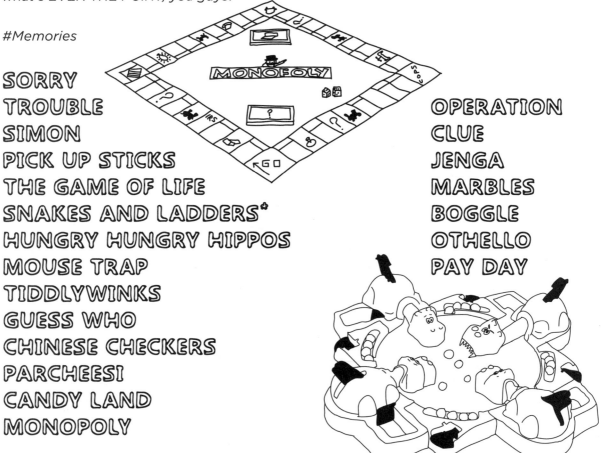

SORRY
TROUBLE
SIMON
PICK UP STICKS
THE GAME OF LIFE
SNAKES AND LADDERS*
HUNGRY HUNGRY HIPPOS
MOUSE TRAP
TIDDLYWINKS
GUESS WHO
CHINESE CHECKERS
PARCHEESI
CANDY LAND
MONOPOLY

OPERATION
CLUE
JENGA
MARBLES
BOGGLE
OTHELLO
PAY DAY

*Fun fact: Snakes and Ladders is the true name of the game, which originated in India during the second century BCE. It was changed to Chutes and Ladders by Milton Bradley, who didn't want to scare the kids—not knowing that within a few short decades most ten-year-olds would have access to chat rooms and also have seen *Snakes on a Plane*, both of which are way scarier.

```
H U N R T P O S U A O W A N S P K Q M A B J T A E C B E S G
K S N G A I G R K V G Q P X F Q I U O O Y D F G B N U Q R J
T E P Y V P D D H J O R R N L L O L Z C V D L N C L W A E B
V K D M X X M D V I P V Q X A D B M W F Q W V E C O E W K H
Y A Y Y A V E T L J C V V L C I B V X Z V K X J K U G K C B
Y R F T J N I R Z Y Y S Q X X Q R Q N V L T F A L H C O E W
O G R Z U D S G H Z W G K Q R F W K D W W T I V R Q P A H C
G Y Z O C D O N F W H I S C X J Q I C B L N C C T E X E C U
I M R P A Z U Y L Y T S N F N D G Z A O M X H A R C F G E R
R C T R G S I A I M M S D K R Y B A N G N G D A A W J O S U
V V G P I C K U P S T I C K S T G Z D G Y U T L N L V F E R
S O P P I H Y R G N U H Y R G N U H Y L L I Y V B S G Y N W
E N G Q A V G H O V L L B U M P Y A L E O E P A E C B E I C
E N B Y R L J E L N X M K O K C A E A N P E F F Q Y L Y H G
M A R B L E S X F O Z J C S K K L K N M O E O T D M M B C M
V F N E O U T V Y C H Q B X R B F E D L N F V X P P N I Y S
S F C F P X L H M B O W K D U E F J A C O Y M I F M L D F L
I S E E H C R A P R A W S O A I D A S M M B I M I J E W V K
S S B T T T E K C Y G R R S L E R D O I T N I G O N G V T H
J S V H X P U O S R P T L F E P W R A O H Q O X K J Z T R K
M P G R Y L D W Z U Z A O Z U U K V I L N C G T W V S D O B
E G N H N S D P H I O E W C J K G P N S D N S Y H Z A C H L
E H W M F V K R H X M P A R T E S U O M Q N O D W E Q J I G
I G M J Y P C R O A Y R R O S L T K T C J D A M A B L E W S
N N Z B S J J Q G A N Y A V Q I Q W E W W Z P S I Q P L S X
F Q Q M B U J E Z R W L S S G A C N I X L Q M Z E S Z C O G
R C G Q Z U H M Y H R W I X Q Y I L L D Z Z B F M K S K T G
O O I W U T T P S O C W F G H P F T P P T X D A O N A K Y T
I B A R I X L C J C D N A U F U Q W T F O V Q J Y H U N U J
F Q L Z Y X Q X B I F Q R F W D Y M Y P X S B B K X M T S K
```

Bonus Rounds:

- Circle the ones that you played.
- Cross out the ones that you owned but never played because come on, nobody *actually* "plays marbles." And you obviously did not play Tiddlywinks, either, because if you did you would have died thirty years ago, at minimum.
- Which of these games still makes you feel rage-y because it was the worst, and also depressing, and also much more like "working" than "game-playing"?
 » Was it Pay Day? You are correct.

MAKE A MACARONI
NECKLACE BECAUSE SURE

Honestly, some fashion person will probably pay good money for this thing once you're done with it. #ontrend

How to do this: Pretty self-explanatory, but if you're not in the mood, here. Just pretend pasta has a color other than "pasta color," color in this one, and call it a day.

THINGS YOU CAN BUY ON ETSY THAT YOU CAN ALSO MAKE AT HOME

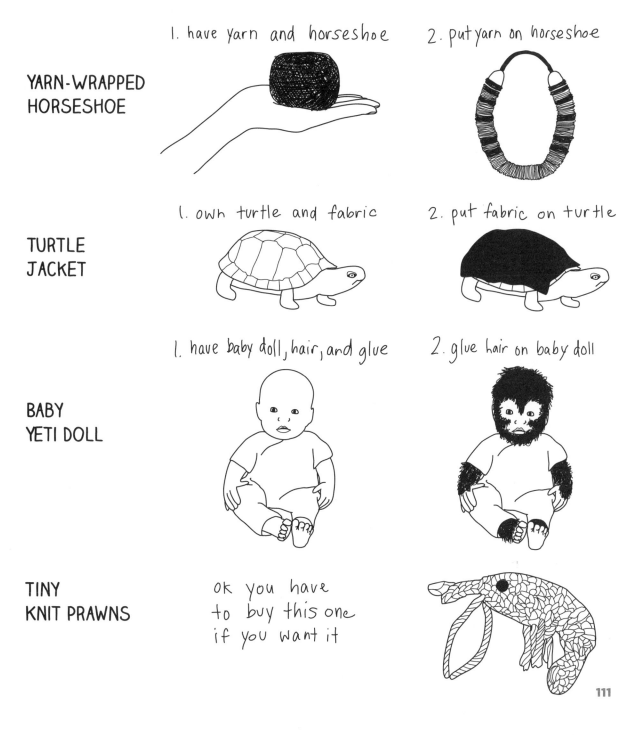

YARN-WRAPPED HORSESHOE

1. have yarn and horseshoe

2. put yarn on horseshoe

TURTLE JACKET

1. own turtle and fabric

2. put fabric on turtle

BABY YETI DOLL

1. have baby doll, hair, and glue

2. glue hair on baby doll

TINY KNIT PRAWNS

ok you have to buy this one if you want it

The digital world is a compelling one, rife with information, sparkly distractions, and filters that make you look like a baby, and disconnecting from all this gloriousness can be hard. Which is why we're not telling you to disconnect—we're telling you, very simply, to move your gaze five inches upward every once in a while and see what you find.

There's good stuff out there. All you have to do is look for it.

SORT OF WISH THESE THINGS WERE STILL AROUND, BUT EH

Saber-toothed tigers

← pretend these are tan

bob barker

Cassette tapes

Also these:

1. _____

2. _____

3. _____

HOW TO:
SURVIVE AN ANALOG NIGHT IN

Plan ahead. Anyone who may feel compelled to contact the police if they're unable to reach you for 45 minutes should be given a heads-up.

Talk to people. Try to remember how to communicate effectively without the aid of Beyoncé GIFs.

Read a book. It's like a TV, but in your head!

Go to bed. Skip the part of the night where you bring your phone and spend 3 ½ hours scrolling through your ex's Twitter feed and rewatching 10-year-old Jackass episodes that weren't even funny the first time. Go to sleep.

TAKE A
BRAIN DUMP

It's like taking a dump. But for your brain! (In a good way.)
There are two ways to do a brain dump: 1) Task-oriented, and
2) free-form.

Task-oriented: Write down all the things you have on your to-do list, no matter how tiny. Now they have been freed from your brain, and you can just check them off! Much less stressful.

Free-form: Write down whatever pops into your head. Yes, *whatever*. It doesn't have to make sense. Aaaaand . . . go!

WHY GARDENING IS A THING YOU SHOULD TRY

Circle the main justifications to buying some seed packets STAT.

Spiritual communion with new life. Or something

No one else wants to do it so you get to be alone

fuck you

Can grow weed

Adorable accessory options

And hats

"TOMATOES"

MATCH THE PLANT TO ITS FABULOUS USE

1. Peek-a-boo plant

2. Elephant foot yam

3. Marjoram

4. Lady ferns

5. Poppies

6. Bloodflower

7. Alfalfa

8. Sage

9. Blackberry leaves

10. Greenthread herb

11. Feverfew

(a) UTI relief

(b) Liver and bowel cleanser

(c) Migraine relief

(d) Dysentery treatment

(e) Anti-inflammatory, antioxidant, anti-fungal, basically good for everything

(f) Ease burns from stinging nettles

(g) Toothache remedy

(h) Hallucinations

(i) Worm expellant

(j) Medieval love potion

(k) Last-resort food source

ANSWER KEY: 1. g; 2. k; 3. j; 4. f; 5. h; 6. i; 7. b; 8. e; 9. d; 10. a; 11. c

THINGS YOU CAN DO WITH YOUR HANDS!

Hands! They're much more than transportation devices for your phone.

They're actually quite . . . handy (sorry).

Play Extreme's "More Than Words" on the guitar and cry a little because it's so beautiful

Make the Notre Dame Cathedral out of Popsicle sticks

Itch something itchy

Make a sponge cake

Try on lots of gloves

SCAVENGER HUNT: AT HOME

- [] A note or letter from someone you love

- [] A pen that actually works

- [] A burned-out light bulb (Bonus: Change it!)

- [] Ice cream

- [] Something that makes you smile immediately

- [] Something one of your grandparents gave you

- [] A mug someone at work gave you

- [] Something that's expired in your refrigerator (Bonus: Throw it out!)

☐ A jacket you can donate to charity (Bonus: Actually do this!)

☐ Something creepy in a corner

☐ A remote, charger, or cord for a device that you haven't owned in a decade

☐ A photograph of your family when you were a baby

☐ A stray hair
 (Extra points if it doesn't belong to you)

☐ A favorite book you haven't read in forever

☐ Something with a picture of a cat on it

10 THINGS
TO DO OUTSIDE RIGHT NOW

1. Climb a cool tree.

 Draw a cool tree

2. Go for a walk down this great street: _____.

3. Spy on your weird neighbors, _____ and _____, and hope they are _____.

4. Look at the stars with this person: _____.

5. Pick up garbage in this park: _____.

6. Read this book you've been wanting to get to: _____.

7. Mind-altering substances. Your favorite: _____.

8. Befriend a squirrel.

Draw your fun new friend

9. Play this sport you really loved when you were a kid: _____.

10. Put those little rain booties on your dog and make him walk around in them. (Always funny; never gets old.)

Good for bird watching and
spying on your neighbors

LOOK UP. RIGHT NOW. WHAT DO YOU SEE?

Draw it.

DIGITAL DETOX CHECK IN

I haven't looked at my phone in _____ minutes.

I feel _____ about it.

If I were going to look at my phone, which I am not, the first thing I'd check is
_____ because _____.

But instead I am here, holding an actual book made out of paper and holding
a _____ with which to write.

When I close my eyes, the first image that comes to mind is of
_____. I hear _____.

I smell _____. I feel _____.

The best non-digital part of my day was _____.

The worst non-digital part of my day was _____.

Here is something non-digital that I will be doing in the near future:
_____. I feel pretty _____ about it.

TOP 5:
FAVORITE SONGS TO DANCE TO LIKE A TOTAL WEIRDO

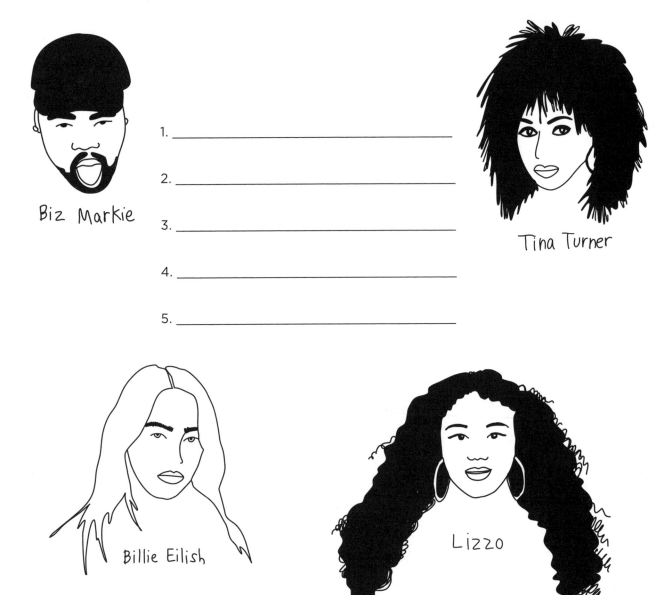

Biz Markie

Tina Turner

1. _____

2. _____

3. _____

4. _____

5. _____

Billie Eilish

Lizzo

THINGS THE INTERNET
SUCKS AT

1. Helping you do anything that requires a government service's or agency's support.

2. Providing you with answers that you can be absolutely certain are accurate, and were not, in fact, generated by a robot or a twelve-year-old on his older sister's computer who thought it'd be fun to write that the definition of a "blumpkin" is a "blue pumpkin" and *not what it is.**

3. Cultivating a sense of deep connection with the universe.

4. Keeping your naked selfies off the fucking Cloud so they don't pop up on the automated slideshow that plays on your TV at the exact moment when your dad arrives for dinner. (Just us?)

5. Hugs.

*A "blumpkin," according to Urban Dictionary, is when a "male" (presumably a human one, but who knows) receives "genital stimulation" while pooping. Aren't you glad you know that? The Internet is, on occasion, magical.

SCAVENGER HUNT: A WALK AROUND YOUR BLOCK

☐ A bird in the air

☐ A sparkle in the sidewalk

☐ A good omen

☐ A cloud that looks like someone you know

☐ A treasure (whatever that means to you)

☐ A coin

☐ A crack in the sidewalk that looks like a letter

☐ A bird not in the air

□ Something that smells good

□ A bug that is kind of cute

□ Something that smells
not-so-good

□ A tree that makes you happy

□ A bug that is super not cute
in any way at all

□ Someone who smiles back at you
when you smile at them (try not
to be creepy about it, K?)

□ A piece of trash (Bonus: Pick it up!)

**DOUBLE-SUPER EXTRA BONUS:
TAKE A DOLLAR BILL WITH YOU.
HIDE IT FOR SOMEONE TO FIND LATER.**

PLACES TO GO IN REAL LIFE

It's a big, big world out there. If you take a moment to look, you just might see something beautiful.

Where do you want to go?

1.
2.
3.
4.
5.

Bonus: Where are you going to go within the next twelve months (preferably because you're gonna book your trip this very moment)?

What do you want to see there?

MARIE KONDO THESE ITEMS RIGHT ON OUT OF YOUR LIFE

Marie Kondo might be a little crazy—we are 100 percent comfortable in the assertion that socks do not, in fact, have feelings—but she is also right. We have too much stuff. We do not need this much stuff. And we definitely do not need these things:

1. One of the two cherry pitters you somehow own
2. That white T-shirt with pit stains
3. All the hotel shampoos
4. All the DVDs
5. The CDs you're saving for "the next time you're in a rental car"
6. That one glove
7. Wrapping paper scraps that you kept in case you had to wrap a very tiny box one day
8. Wine corks, even from fancy bottles

I will release the below item(s) from my death grip when hell goes ahead and freezes over, thank u:

(a) My ex's college sweatpants, because ain't no sweatpants like an ex's college sweatpants
(b) My ceramic pot full of cold, bare orchid branches, because you never know
(c) My collection of condiment packets, because a sriracha emergency is always right around the corner
(d) Tupperware containers missing their lids because my mom told me to never give up on a dream

7 NON-DIGITAL HOBBIES TO CONSIDER ADOPTING

If you're going to invest in a new skill, might as well get weird with it.

1. Parkour. Learn to leap tall buildings in a single bound. Like Superman, or a Navy SEAL on speed.

THE BIG ACTIVITY BOOK FOR KNITTING AERIAL PARKOUR ENTHUSIASTS WHO PLAY THE TAMBOURINE

YOUR NAME HERE

2. Competitive dog grooming. Please take a break from your digital detox to google this. You will not be sorry.

3. Aerial yoga. Everything you love about Vinyasa flow, minus the "relaxation" part, because you are twenty feet above the ground, hanging by a piece of string.

4. Writing activity books. Mine would be about:

_____.

5. Spinning dryer lint into yarn with an old-fashioned spindle. Then just learn to knit, and you can turn your creation into a blanket for the next baby shower you're invited to! Frugality!

6. Tambourine playing. Entertain all your friends with your dulcet melodies.

7. Slinky untangling.

HOW TO: FENG SHUI
(FOR, YOU KNOW, PEACE)

Feng shui: The art of moving your crap from one place to another place, and thereby finding happiness.

Rules for optimal feng shui-ing (because putting all your shit in the closet and closing the door doesn't count):

1. Don't own a cactus. Or dried flowers. When it comes to plants, think "alive" and "ones that won't make you bleed."

2. Don't sleep with your feet pointing toward the door, because according to Chinese tradition, that's how dead people are carried out. (Uplifting!)

3. Get rid of broken and expired objects, because you are what you surround yourself with, and you? You are whole! And unexpired!

4. Toss the "hilarious" *Dilbert* desk calendar Carol gave you at the office Secret Santa party. Unwanted gifts = bad energy.

5. Get rid of all your extra paper. Definitely include "bills I don't want to pay" in this category.

6. Don't have a mirror facing the bed. This is a good idea for many reasons, including the fact that cellulite exists and we all have it.

7. Get rid of all sharp-cornered things. And save your shins in the process!

8. Fact: If you keep live fish anywhere but in your living or dining room, you will be poor.

9. Take out your garbage. Like, frequently.

Feng Shui Alternative: Locate an empty storage pod and sit in it while cuddling a fern. Whatever's easiest.

THINGS TO THINK ABOUT
INSTEAD OF REACHING FOR
YOUR PHONE
TO DISTRACT YOURSELF

1. What to eat next (Answer: Yodels)

2. How you should drink more water

3. How you should drink less coffee

4. The fact that "wrong" is spelled wrong in the dictionary

5. Whether very old people find other very old people attractive, or whether they're just like, "Well, this is my wheelhouse, so . . ."

6. Nothing is ever on fire. Fire is on things.

7. The chances of coming across the same dollar bill twice in a lifetime

8. Why people eat pizza from the inside out

9. Why camera lenses are circular but photographs are generally square or rectangular

10. If the oldest person on the planet is 116 years old, that means that 117 years ago there was a whoooole different set of humans on Earth

11. Why two cats is the maximum allowable amount of pet cats, after which you become a Weird Cat Person

12. Why the amount of time we spent learning to "stop, drop, and roll" as children is so disproportionate to the amount of time we have spent utilizing this knowledge

13. Wolverine is not circumcised.
 That is a fact.

SCAVENGER HUNT: AT WORK

FINAL NOTICE

□ An unpaid bill
(Bonus: Continue ignoring it — you're working on an activity book and you're far too busy for such things)

□ A functioning stapler

□ An actual, made-from-paper desk calendar

□ Alcohol

□ A relic from a bygone era

□ An inside joke

□ Old mail

□ Crumbs

□ A "funny" office cartoon

□ An uplifting quote

□ A reminder to Do the Obvious Thing

□ Something completely inappropriate to keep at work

□ An exciting paper clip

□ A document that you're holding onto for no reason (and can throw out right now)

LOOK UP: THE TOPS OF BUILDINGS ARE OFTEN REALLY, REALLY NEAT.

DRAW YOUR TECHNO-FREE FUTURE

ANALOG MODES OF TRANSPORTATION

Say what you will about the evils of pollution (yes, very evil): You have to admit that it is groovy being able to make it from New York to California without worrying about things like scurvy or whether your oxen might drown in a river. A few more transportation systems that we can all agree should be permitted to slide into the distant, distant past:

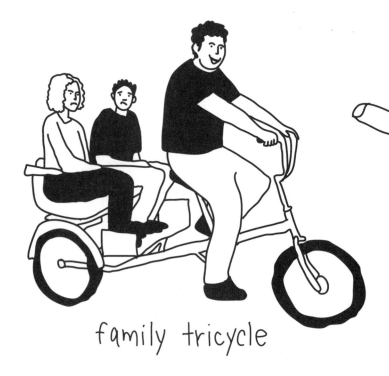

rocking horse
(con: very slow)

family tricycle

balloon dragged by a semi-domesticated elephant

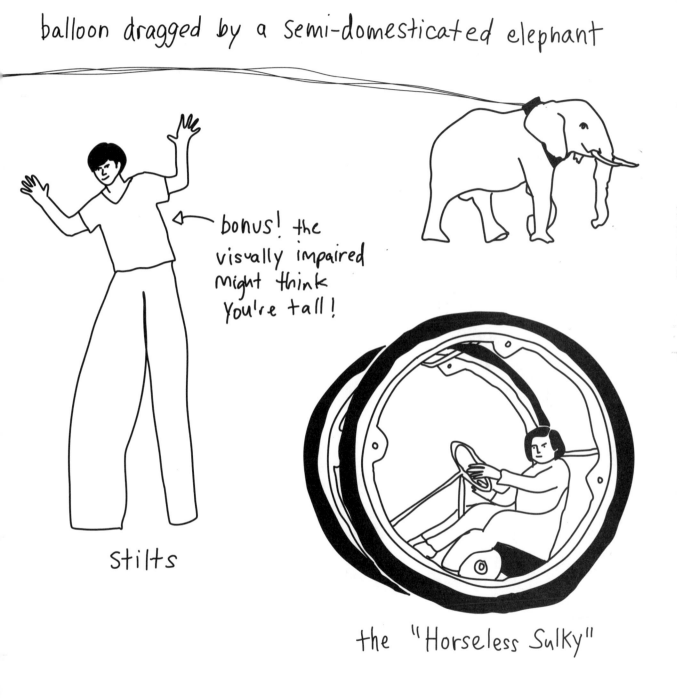

bonus! the visually impaired might think you're tall!

stilts

the "Horseless Sulky"

I strongly disagree, and would like to take a spin on _____ STAT.

A FEW WISE THOUGHTS
FROM A FEW WISE PEOPLE

Alan Watts

The meaning of life is just to be alive. It is so plain and so obvious and so simple. And yet, everybody rushes around in a great panic as if it were necessary to achieve something beyond themselves.

Gandhi

You may never know what results come of your actions, but if you do nothing, there will be no results.

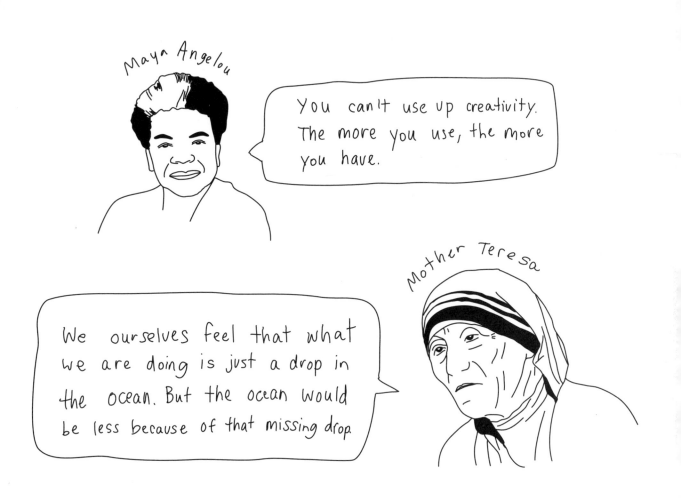

Maya Angelou

You can't use up creativity. The more you use, the more you have.

Mother Teresa

We ourselves feel that what we are doing is just a drop in the ocean. But the ocean would be less because of that missing drop.

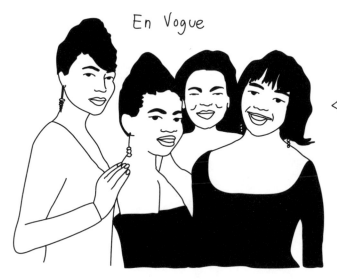

En Vogue

Free your mind.

Also by Jordan Reid and Erin Williams

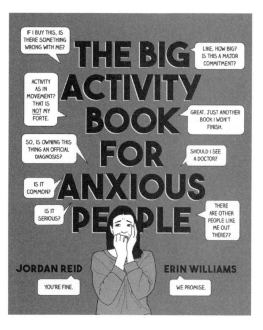